DRAWING FOR JOY

15-Minute Daily Meditations to Cultivate Drawing Skill and Unwind with Color

Stephanie Peterson Jones

QUARRY

Brimming with creative inspiration, how-to projects, and useful information to enrich your everyday life, Quarto Knows is a favorite destination for those pursuing their interests and passions. Visit our site and dig deeper with our books into your area of interest: Quarto Creates, Quarto Cooks, Quarto Homes, Quarto Lives, Quarto Drives, Quarto Explores, Quarto Gifts, or Quarto Kids.

First Published in 2017 by Quarry Books, an imprint of The Quarto Group,
100 Cummings Center, Suite 265-D, Beverly, MA 01915, USA.
T (978) 282-9590 F (978) 283-2742 QuartoKnows.com

Quarry Books titles are also available at discount for retail, wholesale, promotional, and bulk purchase. For details, contact the Special Sales Manager by email at specialsales@quarto.com or by mail at The Quarto Group, Attn: Special Sales Manager, 401 Second Avenue North, Suite 310, Minneapolis, MN 55401, USA.

ISBN: 978-1-63159-295-9

Digital edition published in 2017.

Library of Congress Cataloging-in-Publication Data available.

Interior design & layout: Laura McFadden
Cover design & image: Stephanie Peterson Jones

Printed in USA

I dedicate this book to Pip Jones,
whose love and support allow me to live
a creative life every day.

And to you, the artist. My greatest wish is
that you find and nurture the love of drawing,
and through it, experience great joy.

Contents

From Flow Comes Joy
Take the next step in drawing

Joy Happens
For when you're in the drawing groove

Introduction

"An aesthetic experience is one in which your senses are operating at their peak. When you are present in the current moment. When you are resonating with the excitement of this thing that you are experiencing. When you are fully alive." —SIR KEN ROBINSON

I grew up in a suburb of New York City where there were a lot of kids. When we weren't playing Kick the Can, drinking Kool-Aid, or swimming, we sat around a coffee table with our #2 pencils and a pile of recycled office copy paper and we drew together. Our little community of friends had a drawing practice that would last a lifetime.

Several years ago, my final project for a master's program focused on a daily practice of meditation and art making. My goal was to quiet my inner critic and monkey mind and rekindle my joy of making art for its own sake. The academic goal of the project was to monitor the relationship between the practices and what effect they had on one another.

What I found that was that meditation quieted my mind and I became more present in making art. My approach to making art daily was influenced by and became similar to that of meditation, and I experienced a freedom from the result that I hadn't known before. My busy mind quieted down, and I felt relaxed and peaceful. I felt more like my true self, and that's where the joy happened.

"Authenticity is the daily practice of letting go of who we think we're supposed to be, and embracing who we are." —BRENÉ BROWN

Authenticity is choosing to accept all parts of yourself. In being real, there is freedom and beauty. When your mind wanders in meditation, the instruction is to let it go and bring your attention back to your

breath. No judgment or reaction, just bring it back. Keep going. Think of drawing in the same way: creating one mark at a time. Get stuck? Don't like it? No judgment, just keep going. Let go of the perfection and focus on the present moment.

This process will help you enter a state of flow. Psychologist Mihaly Csikszentmihalyi defines flow as "a state in which people are so involved in an activity that nothing else seems to matter; the experience is so enjoyable that people will continue to do it even at great cost, for the sheer sake of doing it." How will this process help you in art and in life? Consider the following:

It will make you happier.
It will make everything you do better.
It will decrease your stress level.
It will give you a sense of joy and peace.
You will learn about yourself, become more patient, and forgive yourself and others more easily.
You will let go of judgment of yourself and others and learn to trust your gut.
You will have the extremely satisfying state of *flow* and *joy*.

We live in a crazy virtual world, where everything moves like a flash and we're conditioned to believe that there's never enough time to do what we think we need to do. Yet when we stop and give ourselves the gift of time to spend on something creative, we're always grateful for it. Making the time to have an art practice is truly an act of self care, and you'll reap the joy that comes from it, experiencing your life in real time, in the present moment.

Make no mistake about it: Creating art can be frustrating. Many people suffer from artist's block and freeze when they face that white piece of paper. Our inner critic starts to talk to us. Practicing meditation will help you let go of those thoughts and bring you into the present moment, so you can make one mark at a time. Experts say that it takes twenty-one days to create a habit. A year is a long time, I know. I ask only that you do the best you can, and when you miss a day or two, let it go, and just agree to start again. *That is the hardest part.*

The cool part is that as you develop a rhythm of drawing every day, your work will get better. By "better," I mean more authentically you, which is more beautiful. Even more exciting, your practice will extend to other aspects of your life.

My deepest wish for you is that by doing this practice, you know and remember that it's always here for you as a tool for finding joy, authenticity, and peace in your life.

Mindfulness Meditation

It's a scientific fact: Meditation can measurably improve your life in many ways. It will help you focus better, reduce mental chatter, connect better with people, lower your stress level, decrease anxiety, and improve sleep. Why wouldn't you want at least some of those things?

Meditating for a short time, even three minutes, will help you reap more from your art practice as well. Even if you take three deep and focused breaths before you start, it will be better than if you didn't. When I started my practice of meditation and art making, I followed the format offered in *Real Happiness: The Power of Meditation*, by teacher and author Sharon Salzberg. Her instructions, both written and recorded, are readily available.

Mindfulness meditation consists of three simple steps: take a good seat, pay attention to your breath, and when your attention wanders (which it will), return. Set a kitchen timer or the timer on your phone to whatever amount of time you choose. Here's a brief explanation of the practice.

1

Choose a place with few distractions. Whether you're on the floor or in a chair, sit upright. Place your hands comfortably on your lap. Drop your gaze and relax your eyes. You may close them if you wish.

2

Start to focus on your nostrils, your lungs, wherever you feel the breath the most. If it's helpful, you can mentally note inhale-exhale, count one, two, or use a phrase to help you focus. Vietnamese Buddhist monk Thich Nhat Hanh uses practice phrases, also called couplets. One phrase might be *Joy within, joy all around*.

3

At some point, your mind will leave and your attention will go elsewhere. When you notice that happening, bring your attention back to your breath. You may have to do this twenty times in three minutes. Don't judge it. Just come back to your breath. Going away and coming back are at the heart of the practice.

That's it. Simple, but not easy. Yet worth it.

Hello Moment

How to Use This Book

This book is organized by weekly topics and daily prompts, for 365 days. Each drawing prompt is intended to take about 15 minutes and to be fun and engaging. The prompts are also organized sequentially to help you develop your drawing skills. You will doodle, draw borders and textures, and put them all together in more complex ways as the book goes on. This book isn't intended to instruct you to do realistic drawings but, instead, to give you skills and ideas for a meditative drawing practice.

Find your best place and time. It doesn't matter whether it's the kitchen table, your desk, or a coffee shop. What matters is that it's a place where you're likely to do your practice with consistency and few distractions. Turn off your phone.

Have your art supplies ready and know what they do. Use the artist's palette (see pages 20–21) to make a chart of your tools. Sharpen your pencils and ensure your markers have plenty of juice. Set an intention for your practice. It can be as simple as "May I let go of today's outcome," or "May I have abundant creative energy."

The book begins with basic exercises to get your hands moving. You'll practice drawing shapes, lines, and textures as you learn about the elements and principles of art making. Practicing the basics will help you understand how to do things, making your future art making more confident and natural.

In the beginning, you'll receive art starts—light gray lines that will help you with the prompt for the day. If you don't need the prompt or want to modify it, have a sketchbook handy and do your drawing there. A sketchbook will also be helpful when you need additional space or just want to spend more time with that prompt. Sketchbooks come with different paper types, so choose one that works with the drawing medium you like to use. As the weeks go on, you'll gradually move from the basics to more complex drawings, and you'll have fewer art starts.

Because everyone who starts an art practice has had a different experience of art making, the prompts won't fit every person perfectly. Feel free to modify things so they work for you. Review what you know and adjust the exercises to be enjoyable and challenging. Use a wide variety of drawing tools. Add things. Subtract. Adjust the time you spend.

Finally, one of the hardest things to do is to let go of the outcome. There will always be times when you won't like what you have done. Accepting your imperfections and drawing without inhibition can be liberating, and if you're able, it will make your experience deeper and richer. The more you draw, the less the outcome will matter to you.

Mark a circle every day you practice drawing

Bravo!
You did it.

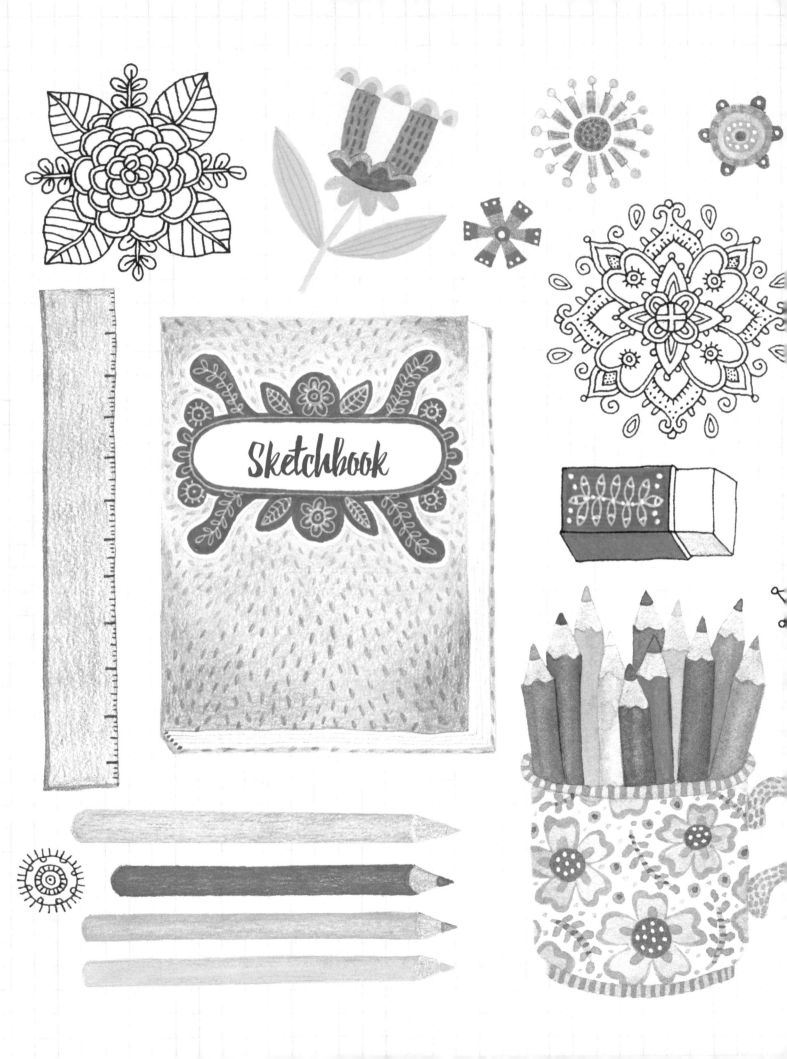

Sketchbook

1 The Essentials

Before you start drawing, have exactly what you need in front of you. Make sure your space is comfortable and free of distractions. Try out a variety of art supplies first and then stick with the ones that feel good and work smoothly for you. Have a cup of tea by your side and listen to your favorite music. Do whatever it takes to create an environment where you're happy, and set your intention to joyfully take some time for yourself.

What Do I Draw With?

Let me first say that I'd love for you to just use your pen of choice most of the time as you move through this book. I want you to draw confidently, without hesitation or frequent erasing. There's a confidence in a strong black line. That said, you should play with many other materials so that you find what's best for you. There's an endless supply of drawing materials available, so I'm going to go through a few choices and let you decide what to work with. Here are some of the different types of pens and pencils and their unique qualities.

PENS

Ballpoint Pens These are great because you can get a variation on line by changing the pressure. They come in a variety of colors and are inexpensive. Bic makes a good one.

Roller Ball Pens These contain liquid ink and glide across the paper. They come in a variety of line thicknesses. I like the Pilot Precise and the Uni-Ball Vision.

Gel Pens These contain gel ink similar to but thinner than that in a ballpoint pen. They create bold, vibrant lines and are comfortable to use. Sakura makes a line called Gelly Roll, which comes in many colors and a variety of styles, such as metallic and stardust.

Felt-Tip Pens For drawing, my favorite felt-tip pen is the Sakura Pigma Micron. It has a variety of tip sizes and styles and uses a wonderfully rich, waterproof ink, making it easy to use with wet media.

White Pens I *love* white pens. They're great for drawing on black paper but you can use them to draw over colored or inked areas to achieve strong contrast. I use a Uni-Ball Signo Um-153, but there are many others available. They work best on a matte (nonshiny) surface.

If you're not ready for those strong and confident pen marks, here are some pencil and eraser options. You should have an eraser, but try not to use it often.

PENCILS

Wood Pencils Wood pencils with graphite inside come in a variety of hardnesses, from 6H (very hard) to HB (middle) to 6B (very soft). With a very hard pencil, you get a light line that won't smudge easily. With a soft pencil, you get a creamy, dark line that smudges, which can be helpful for shading. I use Staedtler Mars Lumograph. You need a sharpener for these.

Mechanical Pencils Mechanical pencils are good because there's no need for sharpening and the graphite retracts into the plastic or metal shaft, so it won't break. Just add more graphite as needed. My go-to mechanical pencil is a Pentel Twist-Erase.

ERASERS

Pink Erasers Pink erasers are your basic rubber eraser found at the tip of your pencil. They contain pumice, which can be abrasive on your paper, and they leave eraser dust.

White Erasers White erasers are made of soft vinyl. They erase well and the dust clumps together. They are easy on your paper. When they get dirty, you can trim them with a craft knife. I use Staedtler Mars brand.

Kneaded Erasers You can mold kneaded erasers into different shapes to erase or highlight tiny areas. The graphite on the eraser disappears when kneaded back in, and these erasers do not leave any shavings. Prismacolor makes a good one.

Adding Color

Although drawing is the focus of this book, I hope you'll use lots of color in your drawings. There are so many great and fun coloring materials that it seems unfair to recommend some and not others, so I've listed what I use and have used to create the illustrations for this book.

If your budget allows you to choose just one coloring medium, I suggest a nice box of colored pencils. They're easy to use, transport well, and can be layered and blended to achieve a variety of effects.

COLORED PENS

You can use these for drawing and coloring. They're great for creating fine lines and adding details and accents to your art. Gelly Roll pens by Sakura come in a variety of fun colors and styles, such as metallic, neon, and raised opaque ink.

MARKERS

There are many kinds of markers. Some (Crayola) are waterproof and have thin, thick, brush, or chisel tips. Some (Copic) are better for small areas and others for broad areas where you want a smooth wash of color. They come in sets or individual colors and range in price. Check out the variety at your local art-supply store and choose a set that has bright as well as pastel colors.

COLORED PENCILS

I've always used Prismacolor colored pencils. They come in a variety of set sizes. I recommend buying as large a set as you can afford. Also get a colorless blending pencil, which will allow you to smooth the color on your paper or blend colors together.

WATERCOLOR PENCILS

Watercolor pencils can be used either as colored pencils or as watercolors. I have a set by Derwent. You can use this medium in many ways. I like to add water to part of an image I've colored with them, or to layer a wash of watercolor, let it dry, and then go over it with colored pencil. See also Week 27, My Drawing Meditations (pages 86–87), which uses the wet-in-wet watercolor technique.

Your Art Palette

Make a swatch with each of your art supplies using the graphic on this page. It will help you later to easily choose line weights, pencil hardnesses, and colors.

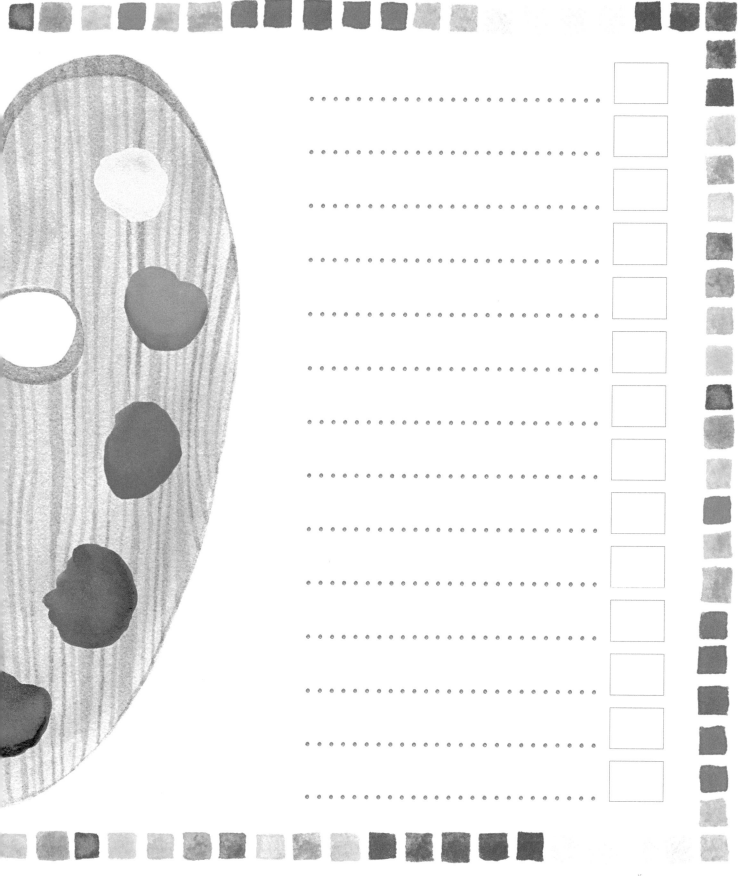

· ·

· ·

· ·

· ·

· ·

· ·

· ·

· ·

· ·

· ·

· ·

· ·

· ·

· ·

Your Artist's License

"Today you are you. That is truer than true. There is no one alive who is youer than YOU!"
—DR. SEUSS

If you've found your way to this page, you're ready to dive in and make some art.

Everyone is an artist. I know of no governing body that defines who is or isn't an artist. I believe that when you create a piece of writing, a song, a painting, or delicious food, you're expressing your authentic self. Doing so is a fearless act of creativity and not for wimps. When you decide to be brave and spend your time doing something creative, you're choosing the courageous journey of the artist. Stick with your practice, and I guarantee it will bring you joy.

"When life shuts a door, open it again. It's a door. That's how it works." —UNKNOWN

We all have inner and outer critics, and we don't have to listen to any of them, especially when the advice we get is less than encouraging. In high school, my guidance counselor told me that I shouldn't bother going to college because I would never make it. Whenever I tell this story, I almost always hear a similar one in return.

You can't let go of these stories fast enough. Don't allow those negative voices to feed your inner critic. Believe in yourself. So many people have been made to think that artistic ability is something you are born with. They think

- I am not an artist.
- I stink at art.
- I have no talent.
- I'm a terrible artist.

Well, take out your boldest pen right now, and cross out the statements above. Reject them completely. Some people do have natural talent, but *all* artists develop their skill through practice, practice, and more practice.

My advice: Don't believe people who tell you that you aren't good enough or shouldn't bother. Perhaps they mean well, but they aren't doing you any favors.

The term "taking artistic license" means that as an artist you have the right to adjust, interpret, modify, decorate, or exaggerate art in any way you desire. I'll add to that by proclaiming that artistic license is giving yourself permission to call yourself an artist and defining what it is for yourself. Sign on the dotted line, and an artist you shall be.

Believe me, you will have fun, and I promise that making art will bring you tremendous joy. So get out your best pen and sign your artist's license.

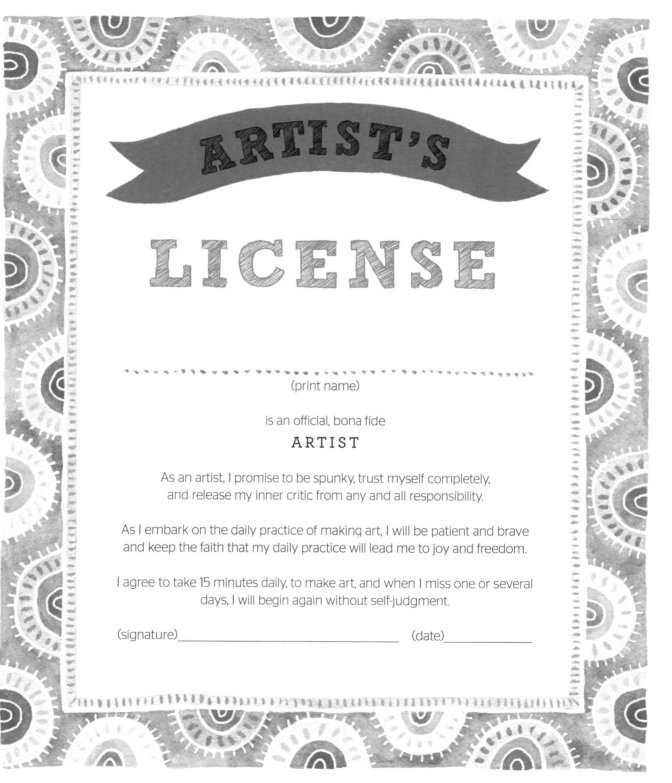

ARTIST'S

LICENSE

(print name)

is an official, bona fide

ARTIST

As an artist, I promise to be spunky, trust myself completely,
and release my inner critic from any and all responsibility.

As I embark on the daily practice of making art, I will be patient and brave
and keep the faith that my daily practice will lead me to joy and freedom.

I agree to take 15 minutes daily, to make art, and when I miss one or several
days, I will begin again without self-judgment.

(signature)_____ (date)_____

The Heart of Making Art

To have a joyful experience making art, you need to have certain tools and practice using them. The elements and principles of art are part of every drawing or painting you'll ever make. When you know about the elements and principles, you will understand where to begin when making a drawing.

In this section, we lay that groundwork by focusing each day on practicing different elements of art and getting used to a variety of materials. You are given art starts along with a prompt in this section to help you get started every day.

The Elements of Art

Without these six building blocks, you wouldn't be able to draw doodly.

Line is the path of a point moving through space.

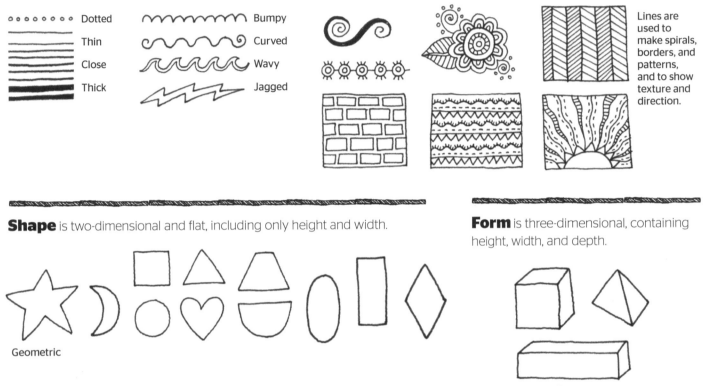

○○○○○○○○○ Dotted	∿∿∿∿∿∿ Bumpy
Thin	Curved
Close	Wavy
Thick	Jagged

Lines are used to make spirals, borders, and patterns, and to show texture and direction.

Shape is two-dimensional and flat, including only height and width.

Geometric

Organic

Form is three-dimensional, containing height, width, and depth.

Form

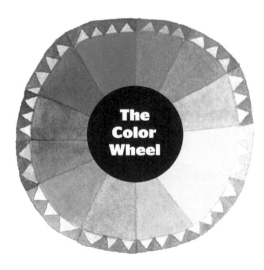

The Color Wheel

Color (also called *hue*) is the reflection of light from an object or a surface, as perceived by the eye. The color wheel explains how colors are mixed and helps us understand the relationships among colors. For more about color, see pages 40–41.

Texture is the quality of the surface or the feel of an object. It can be smooth, rough, bumpy, hard, soft, and so on.

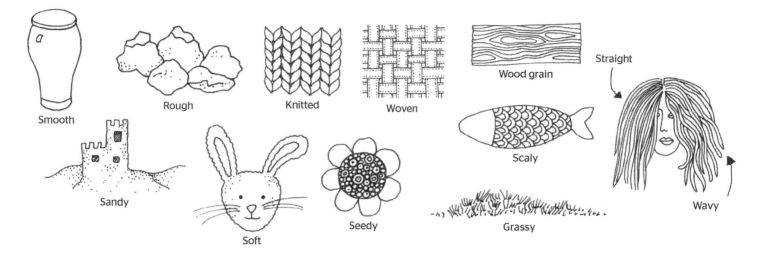

Smooth

Rough

Knitted

Woven

Wood grain

Straight

Sandy

Soft

Seedy

Scaly

Grassy

Wavy

Space is the area between shapes and elements.

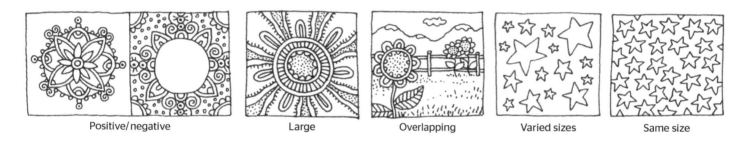

Positive/negative

Large

Overlapping

Varied sizes

Same size

Value is the range of tone from light to dark. There are many techniques to show value, and it can be created with any medium. Value can help convey contrast, highlight, texture, and form.

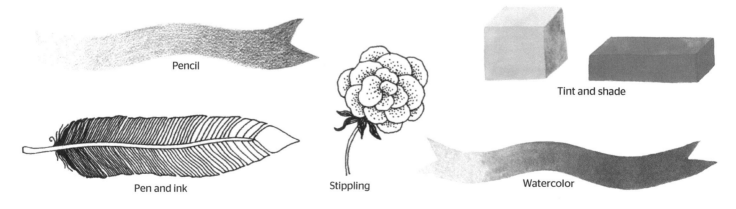

Pencil

Tint and shade

Pen and ink

Stippling

Watercolor

Walk the Line

No matter what, your drawing is going to include lines. There are many types of lines: straight, horizontal, diagonal, wiggly, curved, dotted, dashed, wavy, thick, thin, curly, and spiral (to name a few). To get comfortable making lines, you need to be patient and practice. Try using a heavier weight line to outline primary areas and thinner lines for details. Add color wherever you want.

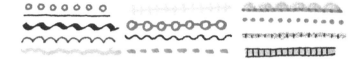

Day 1 Practice drawing lines in the space above. Draw all kinds of lines. Put two kinds together using a variety of media. Go crazy.

Day 2 Using different line styles, draw the edges and stems of the flowers.

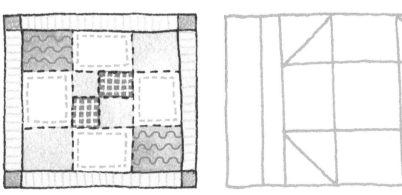

Day 3 Draw over the art start. Begin at the bottom using different kinds of lines. Fill the rest of the spaces with other lines in color.

"A line is a dot that went on a walk."
—PAUL KLEE

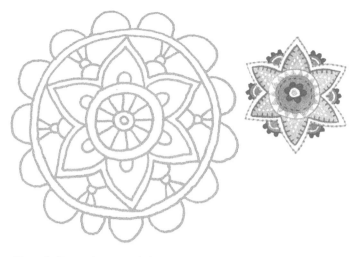

Day 4 Draw the mandala using a variety of line styles.

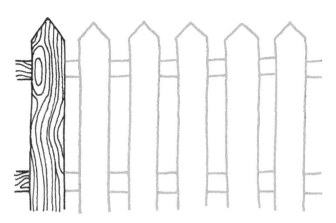

Day 5 Draw the fence and add wood grain.

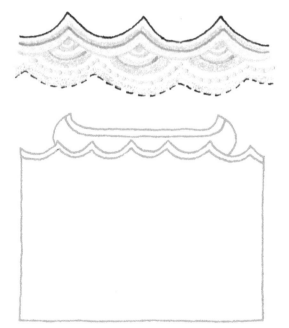

Day 6 Draw the water under the boat.

Day 7 Using different line styles, draw the design to look like embroidery.

Drawing Straight Lines Make two dots where you want your line to begin and end. As you draw your line, keep your eye on the destination, and you'll get a straight line!

Borders

Now it's time to put lines together to make borders. Borders frame a space and can be made from a single line or a combination of more lines or other elements. They can be straight, curvy, zigzag, and more.

Day 1 Using the gray art start, make borders using different line styles.

Day 2 Draw the corners and then the straight lines.

Day 3 Use the art start to make a border from different lines. Draw outside the outer edge.

Day 4 Draw an inner border by making vertical lines from side to side and top to bottom inside all four edges. Draw a decorative element in the corner squares.

Day 5 Draw inner and outer borders using the oval. Make the junction where the borders join as seamless as possible.

Day 6 Draw inner and outer borders, allowing for a wide space between the two. Use the space to make a fun pattern.

Day 7 On each side of the rectangle, place brackets along the outer edges. Putting a dot in the center will help space them. Draw other borders.

Value

Value refers to the range from light to dark. It's used to show how light affects an object, to provide contrast between elements, and to emphasize parts of a drawing.

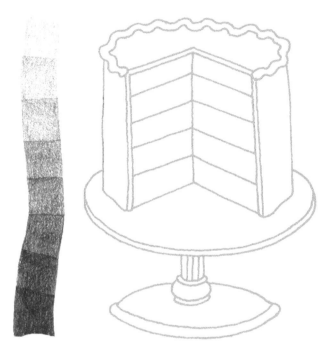

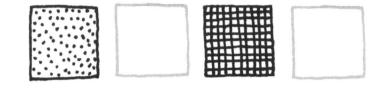

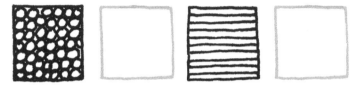

Day 2 These are a few of the many techniques that show value using ink. Practice the techniques in the left boxes in the boxes on the right.

Day 1 Using a graphite pencil, shade the cake layers from top to bottom, light to dark, darkening the value with each layer. Use light layers of pencil to achieve an even, continuous tone.

Using Value (and Temperature) to Create Visual Depth

When drawing a design, keep in mind that dark colors (and cool ones) typically recede, or appear to regress toward the back of a composition, whereas light colors (and warm ones as well) come forward, creating emphasis.

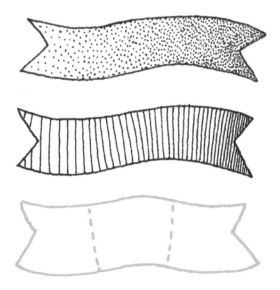

Day 3 Choose two of the techniques and shade the ribbons from light to dark. Spacing the dots, stripes, and so on farther apart gives a lighter appearance.

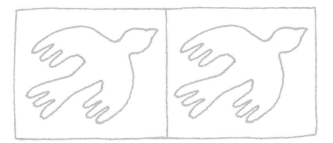

Day 4 Where you place your values can completely change the look of your drawing. Using the medium and style of your choice, add value to the bird in the box on the left and to the background in the box on the right. How does the use of value change each of the frames?

Day 6 A *shade* is a color plus black.
a. Using colored pencil, shade the ribbon evenly with your color and then add light layers of graphite or black pencil from the left dashed line to the right.

Day 5 A *tint* is a color plus white.
a. Using colored pencil, draw very lightly on the left side of the ribbon and add layers of color as you move to the right. To get an even transition, use several light layers of color.

b. Color the flower and leaves using shades.

b. Color the flower and leaves using tints.

Day 7 Apply a variety of colors and value techniques to the mandala.

Shapes

Geometric shapes, which include circles, squares, triangles, and hexagons, are made (and can be measured) with tools. Organic shapes are irregular and have a flowing, natural appearance. They're often associated with animals or plant life.

Day 1 Using dots as a guide, draw four concentric circles. Then draw four more between those.

Drawing Perfect Circles

To get a close-to-perfect circle, keep your eye on the end point of your circle as you draw.

Day 2 Using the grid as a guide, draw circles that touch each other. Add two vertical dots per circle. Then draw circles inside of circles.

Day 3 Connect the dots to make straight lines, making a grid. Draw smaller squares inside every other square. Use other geometric shapes in the remaining squares to make a pattern.

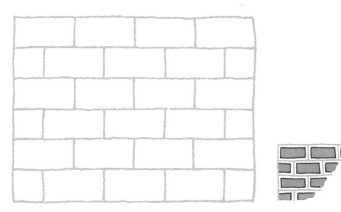

Day 4 Draw rectangles inside the art start to make a brick pattern.

Day 5 Using triangles that share at least one edge, draw a dancing person.

Day 6 Henri Matisse made abstract art using cut paper. Using Matisse-like shapes as inspiration, make your own organic shapes.

Day 7 Draw an abstract piece of art in the frame above using organic and/or geometric shapes. Connect them, overlap them, and vary their sizes.

Creating Form

Form is created when an artist uses a variety of techniques to add the illusion of depth, making a two-dimensional drawing look three dimensional.

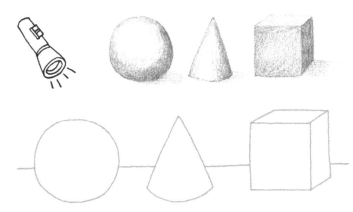

Day 1 Using pencil, shade the above forms and show the cast shadow (on the opposite side of the light source).

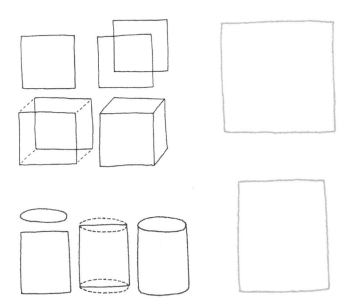

Day 2 Use the art starts to create a three-dimensional form of the rectangle and cylinder using the methods illustrated. Shade the sides.

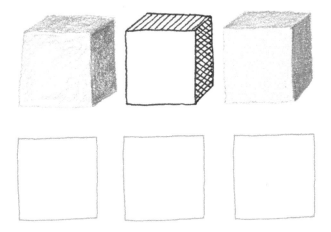

Day 3 Create three cubes, drawing only the lines that would appear in a solid form, and shade one each using pencil, pen, and color (light colors come forward; dark ones recede).

Adding Ovals to Make Spheres

A cylinder is drawn by combining a shape (square, rectangle, or triangle) with an oval. The closer to round the oval is, the more it will appear that the perspective is from above. The narrower it is, the more it will appear to be in front of you.

Lighting Your Drawings

One way to make an object appear three-dimensional is to use value. The area where the light hits the object directly is highlighted and given the lightest value. The area turned away from the light is dark or shaded. To make a circle into a sphere, gradually decrease the value from light (high value) to dark (low value). The shadow alongside the object, where it blocks the light, is called the *cast shadow*.

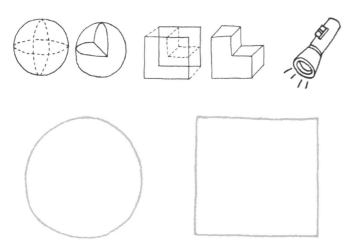

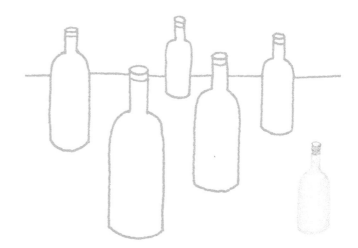

Day 4 Draw a watermelon with a wedge and a square with a piece cut out (making it into a stair).

Day 5 Determine your light source and then shade the bottles, showing foreground and background. Use lighter shades in the front and darker ones in the back.

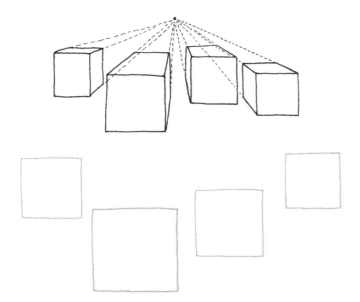

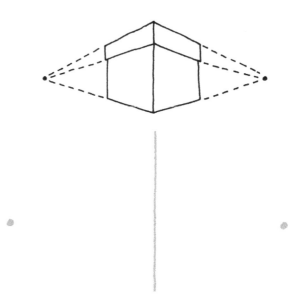

Day 6 One-point perspective: Draw dashed lines connecting the corners of the cubes to the vanishing point and then add lines parallel to the cubes to create the form. Add shading.

Day 7 Two-point perspective: Draw a centerline to the length you like. Connect the outer points to different points above and below the centerline to make a box. Draw vertical lines to finish the box.

Putting Shapes Together

Like the triangle dancer on page 35, putting shapes together can make cool designs. When drawing something *representational*—a realistic object, figure, or landscape—try to see it as a grouping of simple shapes. Use a pencil when doing this week's prompts so you can erase your construction lines.

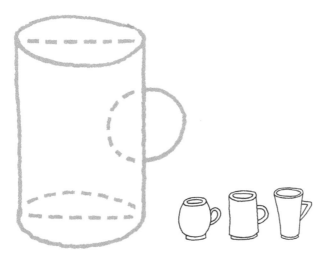

Day 1 Mugs: Combine a rectangle with two ovals (for the cup) and a circle (for the handle). Adjust the shape before inking your lines. Draw another one on your own.

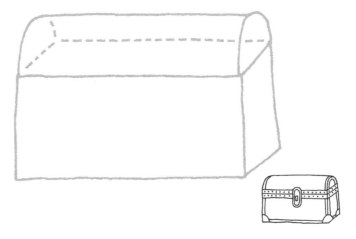

Day 2 Trunk: Make a 3-D box by adding a semicircle to each side of the top. Connect the lines and erase what wouldn't be visible. Add buckles, straps, and so on.

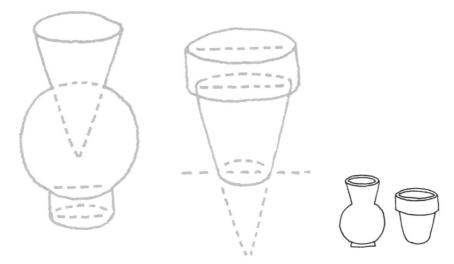

Day 3 Vase and flowerpot: Using the art starts, create a vase and flowerpot. Then draw one more of each, adding personal touches.

Day 4 Flowers: Use the art starts to combine the shapes to make flowers. Add details and color.

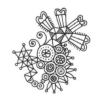

Day 5 Radial design: Start with a central shape and attach shapes in a circular method. Add lines and other shapes.

Days 6 & 7 Make a spontaneous design using geometric and organic shapes that touch each other—go for it!

Color Wheel and Harmony

Who doesn't remember learning about the color wheel back in school? Knowing how colors (hues) are made and the relationships among colors can help you create an endless variety of color palettes that will make your drawings sing.

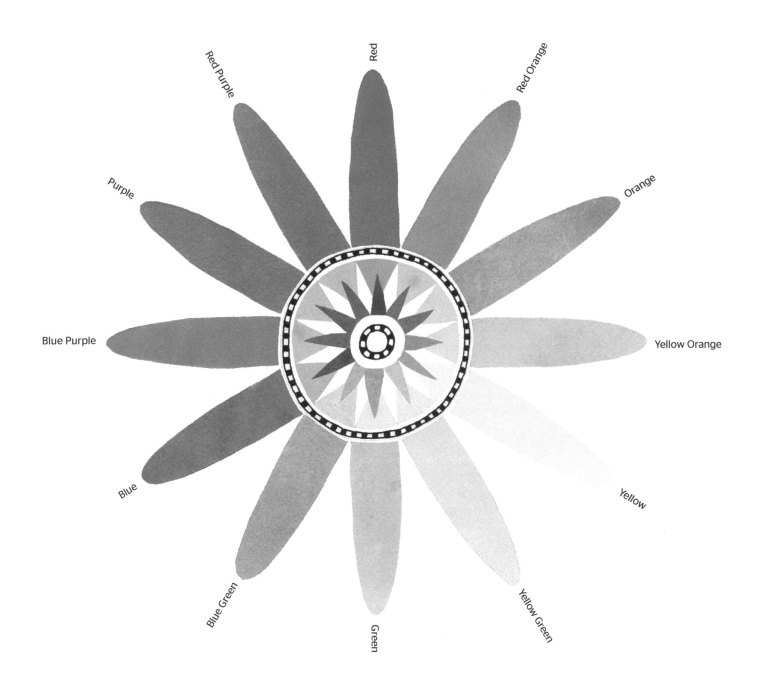

Color harmony means to combine colors in a pleasing arrangement. The human brain rejects chaos, and color harmony gives a sense of visual interest and organization. At right and below are examples for achieving color harmony by using the color wheel to combine colors.

The **primary colors**—red, blue, and yellow—are evenly spaced around the color wheel. Primary colors can't be created by mixing other colors, but they can be mixed to make all other colors.

Secondary colors are made by mixing two primaries together.

Tertiary colors are made by mixing a primary color with a secondary, such as blue green and yellow orange.

Tint is a color plus white.

Shade is a color plus black.

Tones are the color plus both black and white (used to dull a color).

Warm colors—orange, red, and yellow—give the impression of light and energy. They tend to advance visually.

Cool colors—blue, green, and purple—are calm and soothing. They tend to recede visually.

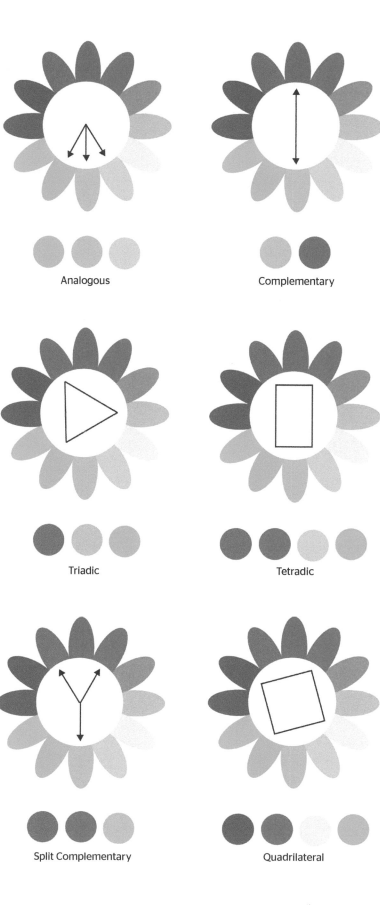

Analogous

Complementary

Triadic

Tetradic

Split Complementary

Quadrilateral

Coloring Flowers

Choosing which color palette to use affects the feel or mood of the artwork. Choose a flower to color using analogous, complementary, triadic, tetradic, split complementary, and quadrilateral color schemes each day this week. Use tints and shades, too! For the seventh flower, choose your own color scheme.

Let's Get Patterny

The repetitive quality of drawing patterns is much like meditating with a mantra, giving you a sense of calm, focus, and peace. This week, we'll draw patterns, practicing a variety of ways to arrange elements as they repeat. Practice keeping the sizes of and spaces between your shapes consistent.

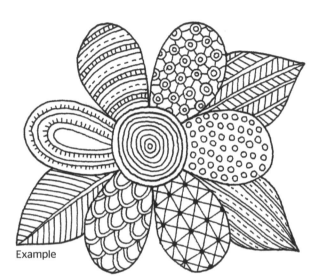

Example

Day 1 Practice filling a shape with a random pattern. Try starting at the edge of the shape.

Day 2 Using this grid as a start, create a symmetrical pattern like those shown in the petals of the flower above.

Day 3 Fill these shapes with concentric patterns (shapes that share the same center).

Day 4 Fill these shapes with stripes. Feel free to vary the line width and style and to add embellishments.

Day 5 Draw a random pattern in these shapes and then connect the elements together.

Day 6 Fill these shapes with different directional patterns.

Day 7 Fill this flower with a variety of patterns.

Putting Patterns Together

Making and using patterns is an art unto itself. Patterns can have light or dark value and can also be bold or soft, depending on how large your areas of black and white are, and the spacing between the marks. The best way to build a pattern is to divide your space into several spaces, divide those spaces again, and then go in and make your patterns. Use the art starts to build patterns as noted within each shape.

Day 1 Build a pattern with scales.

Day 2 Build a pattern with lines, stripes, and diamonds.

Day 3 Build a pattern with circles.

Day 4 Make both bold and soft patterns by varying areas of black and white.

Day 5 Make both dark and light patterns by leaving more or less white space exposed.

Day 6 Divide the square into four sections and fill it with bold, soft, light, and dark patterns.

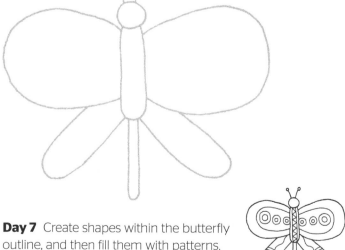

Day 7 Create shapes within the butterfly outline, and then fill them with patterns. Try leaving some spaces white or black.

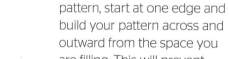

Spacing Patterns within a Shape

When filling an area with a pattern, start at one edge and build your pattern across and outward from the space you are filling. This will prevent you from having awkward spaces where your design doesn't "fit."

Principles of Design

There are rules that artists use when creating art that help make a composition work.

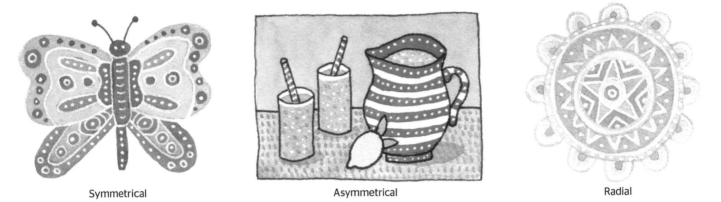

Symmetrical

Asymmetrical

Radial

Balance is the distribution of visual weight within a composition. It can be symmetrical, asymmetrical, or radial.

Emphasis is used to grab the viewer's attention. It can be achieved through size, color, or contrast.

Emphasize the window with a pop of color on a neutral background.

Rhythm happens when an element is used repeatedly to create a feeling of movement through the composition. As in music, visual rhythm can also suggest a mood or energy.

Movement is the direction or path that the viewer is taken along. It can be suggested with line, pattern, color, or edges.

Variety is the use of multiple elements of design to guide the viewer's attention within a work of art.

Unity is a harmonious organization among all parts of the work of art, giving the viewer a sense of completeness.

Pattern is the repetition of objects or symbols within a space.

Repetition works with pattern to make the work of art seem active. The repetition of elements of design creates unity within the work of art.

Finding Balance

In nature and in art, there are many things that are symmetrical. Imagine there is a mirror at the straight/dashed edge of each prompt and practice drawing the reflection of the images below.

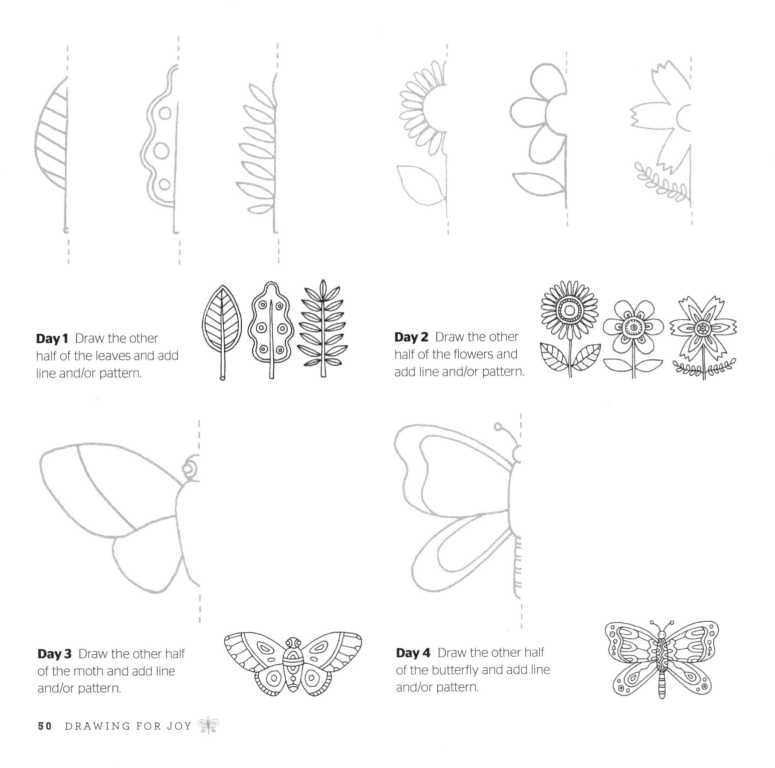

Day 1 Draw the other half of the leaves and add line and/or pattern.

Day 2 Draw the other half of the flowers and add line and/or pattern.

Day 3 Draw the other half of the moth and add line and/or pattern.

Day 4 Draw the other half of the butterfly and add line and/or pattern.

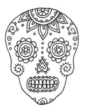

Day 5 Draw the other half of the sugar skull and add line and/or pattern.

Day 6 Draw the other half of the mandala and add line and/or pattern.

Day 7 Draw the open design three more times, mirroring it in each quarter.

Make a Move

Various art elements can be used to show movement and rhythm. Direction, energy, speed, and action are shown and/or emphasized through a variety of techniques.

Day 1 Draw the thread on this spool.

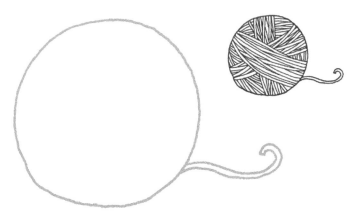

Day 2 Draw the yarn on the ball.

Day 3 Show the sun with its rays shining.

Day 4 Show this planet with a glow around it.

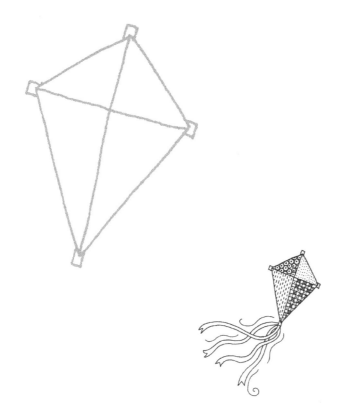

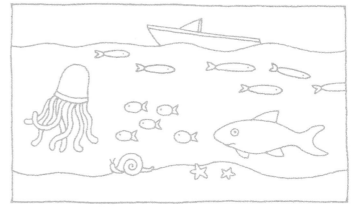

Day 5 Show the direction this kite is flying by adding ribbons and movement lines.

Day 6 Add movement and rhythm to the water and to the underwater scene.

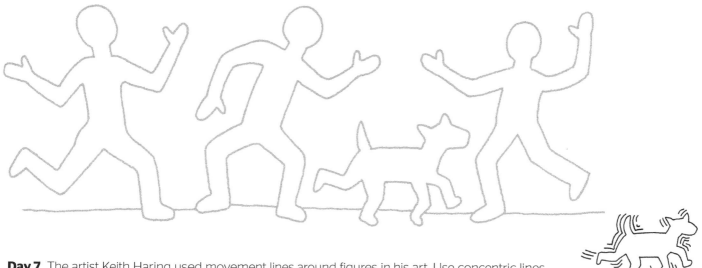

Day 7 The artist Keith Haring used movement lines around figures in his art. Use concentric lines around these figures to make them dance.

Flower Power

This week we work on art starts of flowers and leaves. Have fun using a variety of art elements and principles to add playful patterns and designs.

Day 1 Draw these leaves.

Day 2 Draw groups of leaves on stems.

Day 3 Draw a variety of flowers with petals.

Day 4 Draw round flowers.

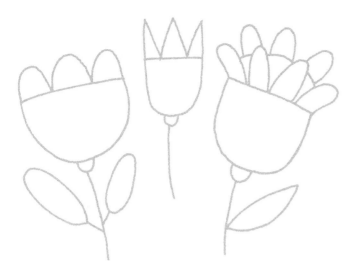

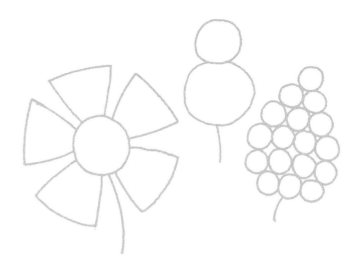

Day 5 Draw tulips.

Day 6 Draw strange flowers.

Day 7 Draw a swag of flowers and leaves.

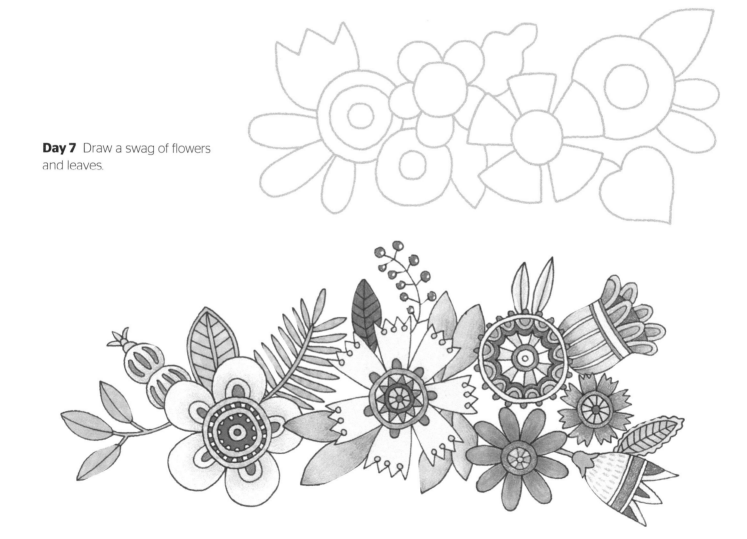

Pattern Play

There is power in pattern. When you repeat the simplest element, it becomes something else entirely, and sometimes you can't even recognize the original image. This week we take simple images and repeat them in different ways using grids as guides.

Day 1 Stripes—elements arranged in rows. Choose a simple element and make a stripe pattern.

Day 2 Tossed—elements randomly placed within a defined area. Choose a simple element and make a tossed pattern.

Day 3 Check—elements spaced evenly both horizontally and vertically. Choose a simple element and make a check pattern.

Day 4 Brick—like a stripe, except every other row is offset a half space away from the elements above and below it. Choose a simple element and make a brick pattern.

Using Overlap in Your Drawings

When you overlap objects to create depth, draw the objects lightly in pencil, overlapping them. When you go back over with ink, draw only the area of the one you want in front. When the ink is dry, go back and erase the lines of the object in the back.

Day 5 Overlapping—elements that overlap each other; they can be positioned in rows, radially, diagonally, or randomly. Choose a simple element and make an overlapping pattern.

Day 6 Basket weave—like a check, except that every other element (or grouping of elements) is rotated 90 degrees. Choose a simple element and make a basket weave pattern.

Day 7 Radial—a design that starts in the center and builds outward in a circle. Choose a simple element and make a radial pattern.

Drawing In and Around

When you break down almost any drawing, you'll find that it's the sum of basic shapes. This week we draw in and around some shapes to make either abstract or representational drawings. Have fun and use the negative space (around and in between elements) as you imagine what each will become.

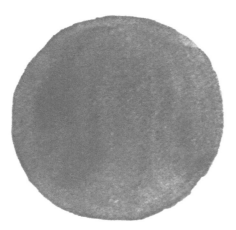

Day 1 Using the circle as a starting point, make a drawing.

Day 2 Use this square as a starting point of a drawing. How do the colors help you decide what to draw?

Day 3 Use this shape as a starting point today. Just because it's shaped like a cloud, doesn't mean it is a cloud.

Day 4 Let your imagination soar as you use this organic shape to make today's drawing.

Day 5 Start with this yellow triangle today.

Day 6 What is it? Whatever your heart desires.

Day 7 How will you use this combination of shapes to make today's drawing?

"To practice any art, no matter how well or badly, is a way to make your soul grow. So do it." —KURT VONNEGUT

Go with the Flow

One of the most important lessons you'll learn from doing art every day is that what you create becomes less precious to you, and the time spent creating art is just as important as what you make. And you will practice more tomorrow. Like life, some days work out fine, others, not so much. Courageously making art with acceptance of the outcome will free your soul and give you joy. This section consists of fun prompts that guide you to practice the things that you learned in the previous section. Each prompt has an art start to help you begin. When you have extra time, get out your sketchbook and practice drawing without the prompts.

Leaves

This week, practice drawing a variety of leaf forms. My examples and art starts represent leaves found in nature. The empty space surrounding them is there for you to make your own leaves, whether from nature or from your imagination. Notice that leaves always grow from the stem outward, and that the veins become more delicate the farther away from the stem they are.

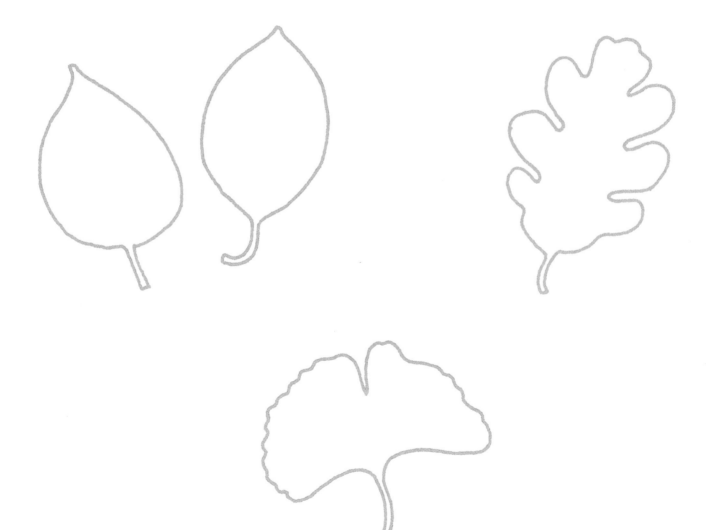

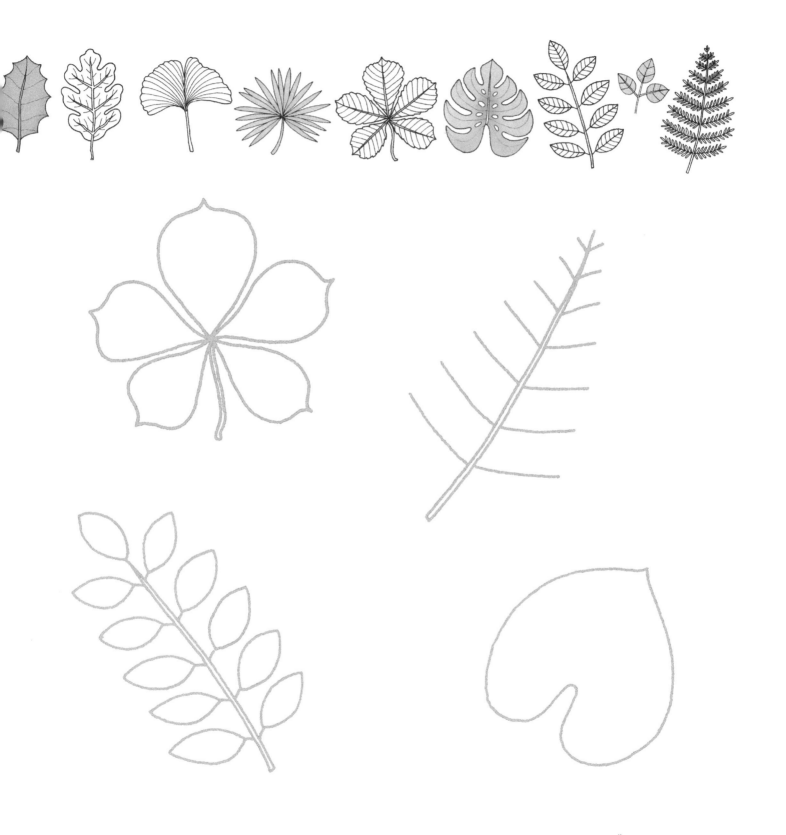

Simple Flowers

This week we practice drawing a variety of flower forms. My examples and art starts represent flowers found in nature. The empty space surrounding them is there for you to make your own flowers, whether from nature or from your imagination.

Notice that the petals on flowers overlap—sometimes more, sometimes less. Draw the petals in the foreground first and then fill with in the ones in the background. Using a pencil, make a dot at each place around the center where a petal will meet a petal; when you have it right, and your ink is dry, erase your extra pencil marks.

Basic Frames

Imagine you're arranging some frames on a wall containing a variety of photos, mirrors, and artwork. Some are fancy and ornate, others funky and geometric. Have fun this week drawing borders around frames, playing with your corners and other decorative elements. As with the flowers (see page 64), use a pencil mark to space your corner or other decorative elements. If you want, find or draw little pictures and fill the insides!

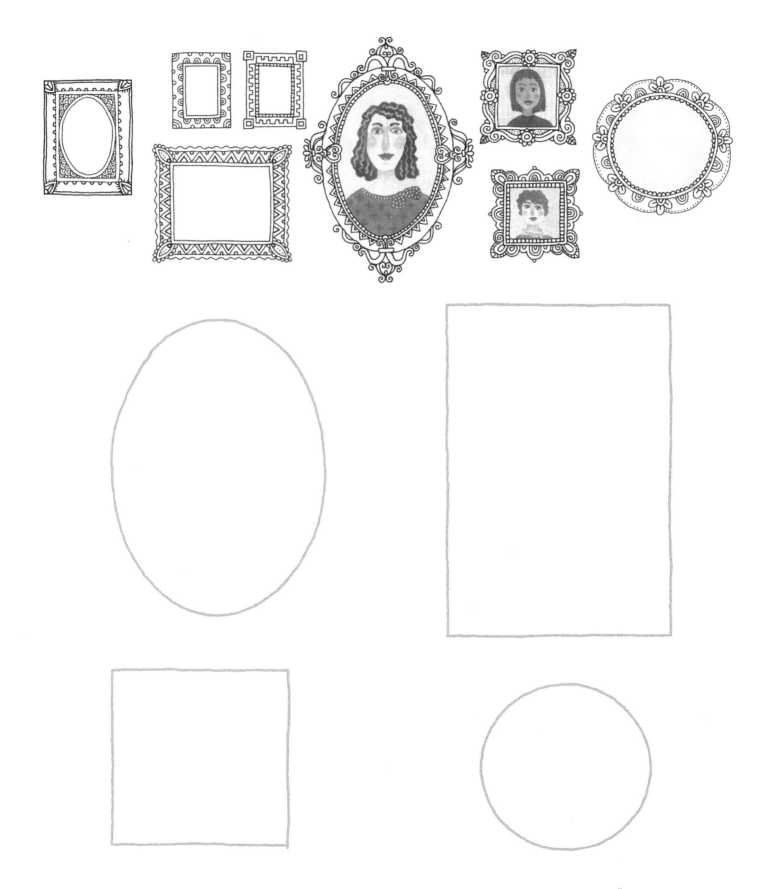

Feathered Fun

If you examine a few feathers closely, you'll find they each have distinctive features that are fun to draw. Some of my examples are based on real feathers and others are not, but this is a form that can be a lot of fun to add your own colors and designs to.

Once again, draw your guidelines for the larger areas first, and then go into each space and draw the smaller details.

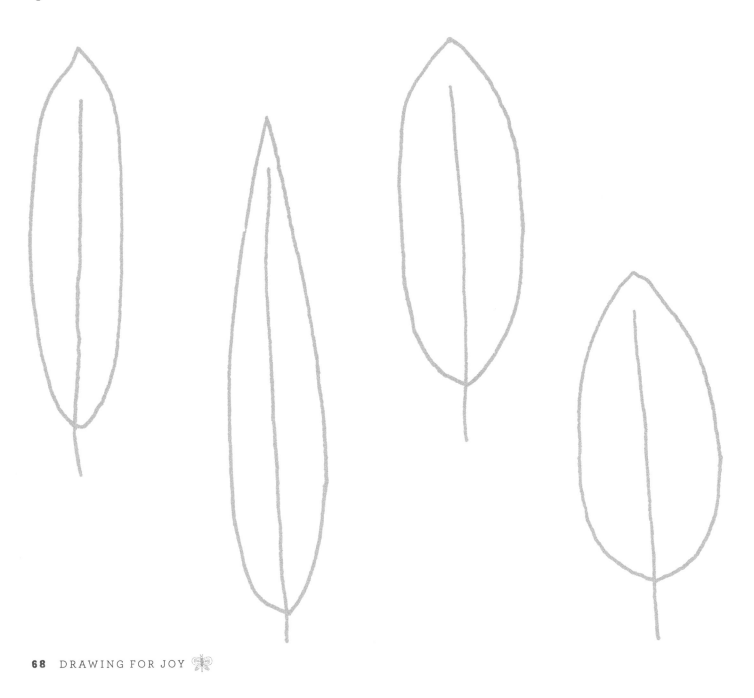

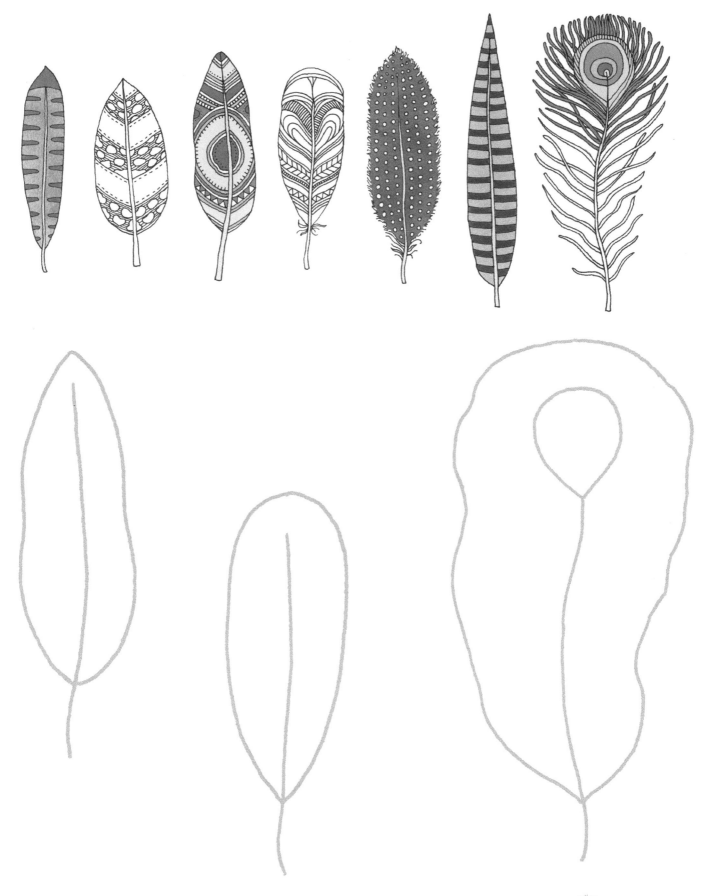

Everyday Textures

Textures tell you what things are made of. They are different from patterns in that they suggest what something feels like and can vary within a form. Using the art starts, practice drawing textures, using a pencil mark to space rows or grids where needed.

Seashells

There are many beautiful seashells in our world. Although my examples are based on real seashell shapes, the colors are mostly from my imagination. Have fun making your own beach booty from the art starts on this page. Once again, draw your guidelines for larger spaces first, and then go into each space and draw the details.

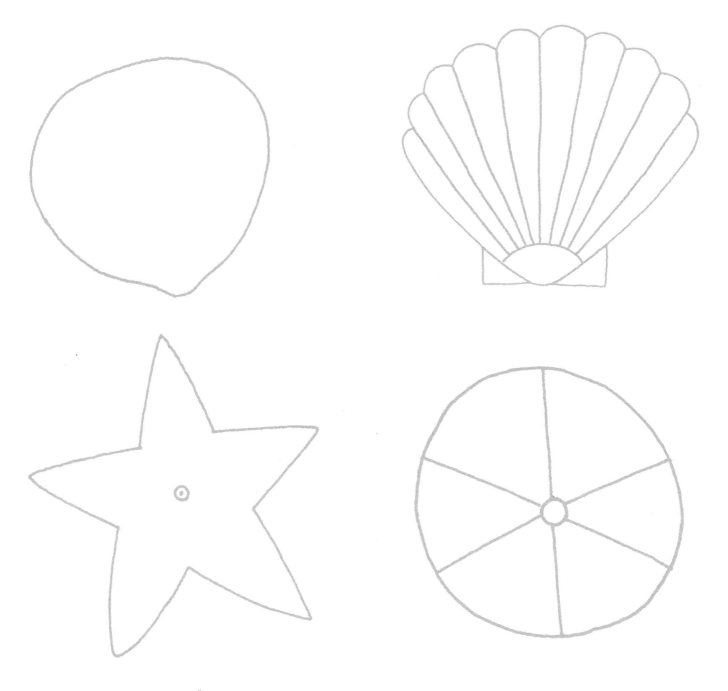

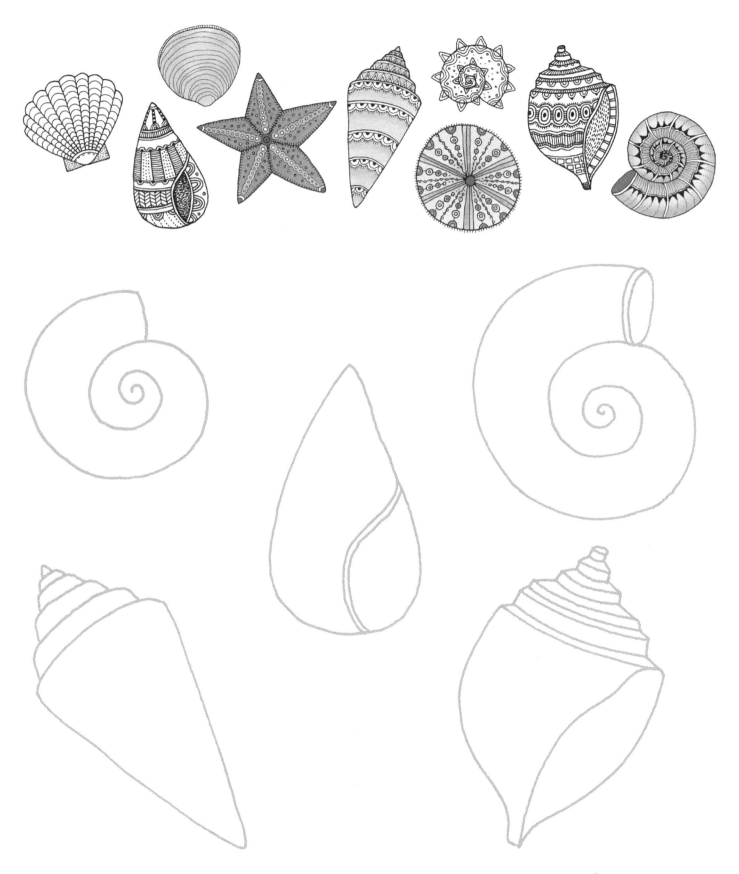

Butterflies and Bugs

The principle of symmetry (see page 50) is key when drawing butterflies and bugs. Use the art starts and your imagination for your shapes when drawing the markings of bugs and butterflies. Believe it or not, my examples are from images found in nature, so the sky's the limit when it comes to colors and shapes. Start by drawing your major divisions of space on both sides, and then go in with a smaller line weight and draw the finer details.

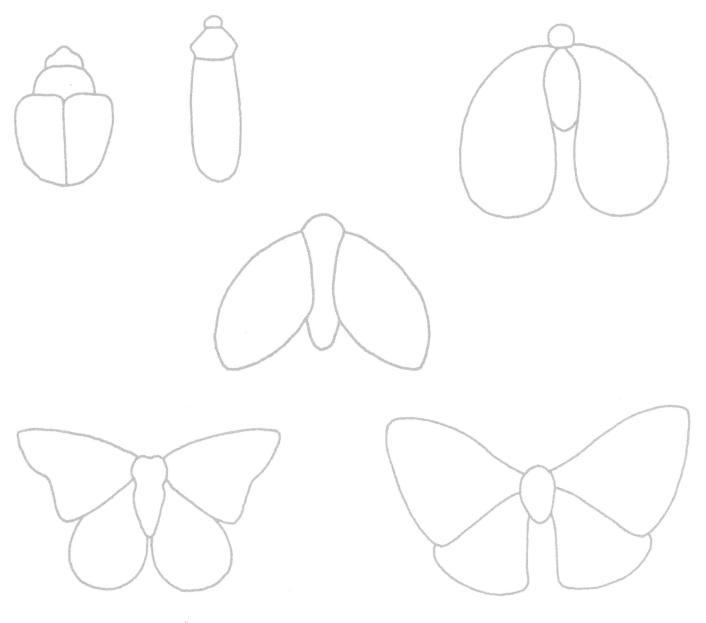

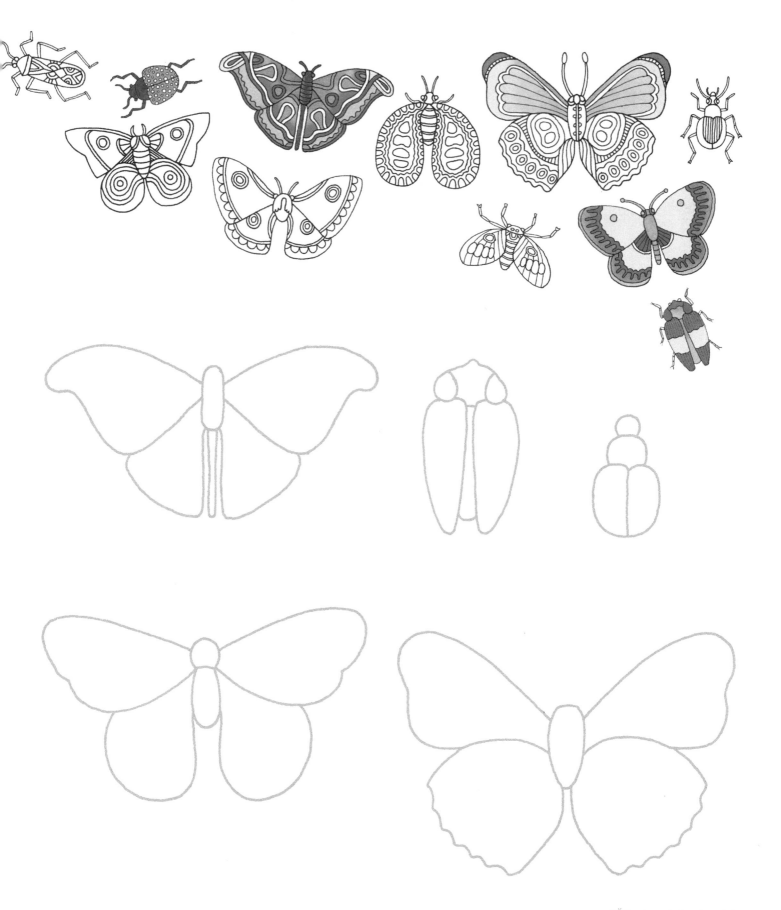

Drawing on Rocks

Having enjoyed a good beach walk or two (another form of meditation), I have many times found perfect rocks and brought them home to paint. These rocks are perfect little vehicles for daily art practice and a great place to experiment with black and white pens. There are enough here for two weeks' worth of drawing, so choose your perfect rocks and go at it!

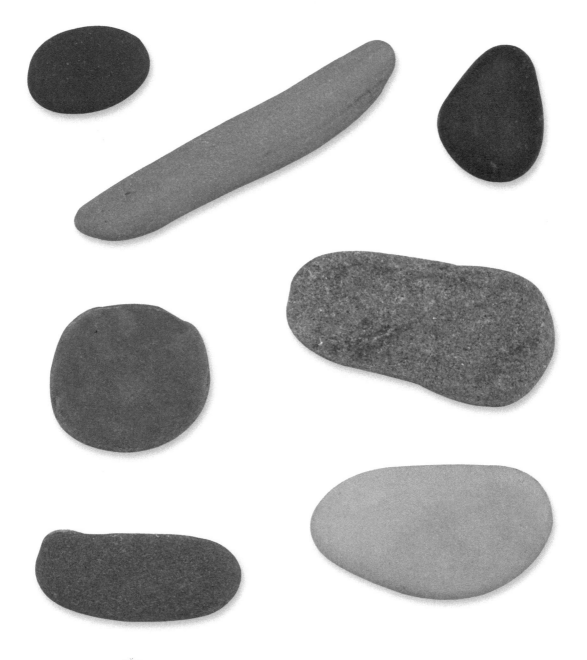

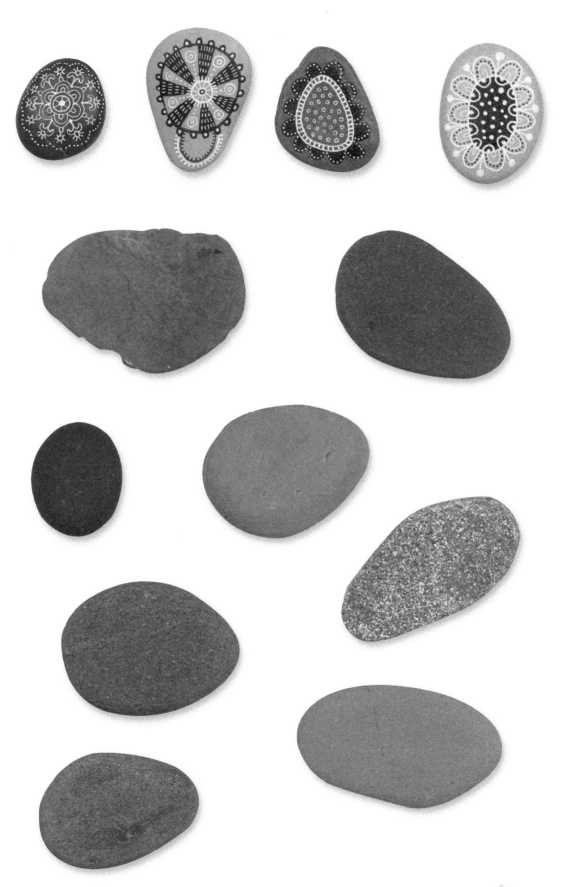

We Built a City

Drawing a cityscape might look complicated, but it's really only a matter of putting a series of shapes together.

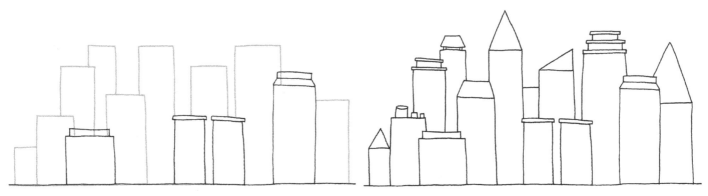

Days 1 & 2 Starting with the buildings in the foreground, add rooflines and architectural details that extend beyond the rectangle for each building. Continue drawing this way, moving toward the background.

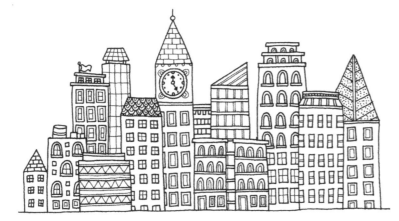

Days 3–5 When you have all the outlines of your buildings drawn, start to go into the details of each building, adding patterns, windows, and other architectural elements. Use light pencil lines to create grids to space your windows floor by floor. Use a lighter pen weight for smaller details.

Days 6 & 7 Add color. Use natural colors or play with color relationships. When drawing a night scene, the light coming from the windows is warm (yellow-gold). When it's day, the color coming from the windows is often cool (gray-blue).

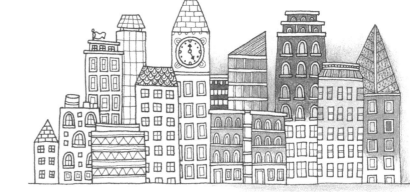

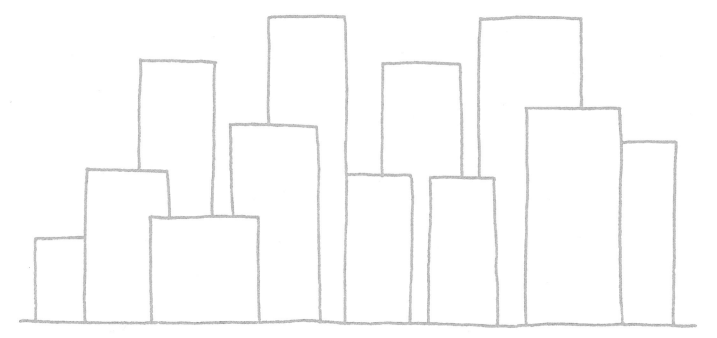

An art start for your cityscape.

Artful Hearts

The heart is the most popular symbol for love and is used in cultures the world over. This week you will practice drawing hearts using these starts from various cultures and traditions. Add borders, patterns, and textures to make them your own. Use the extra space to practice other heart designs.

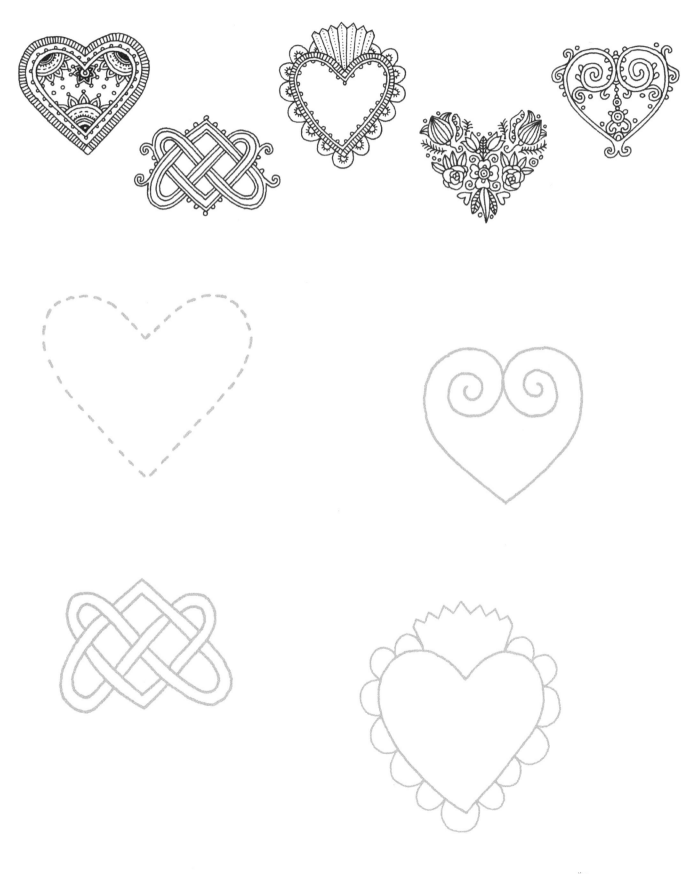

A Little Culture

Many cultures have their own language of symbols, and they often become known worldwide. Within these cultures, artists have made their own variations. Now it's your turn! Add borders, patterns, and textures to make these symbols your own. Use the extra space to invent your own symbols. How would you represent joy, kindness, or courage?

Symbols of Peace and Love

As you build your designs for each motif, consider the meaning of the symbol when choosing your approach.

Peace

Sun Sign

Harmony

Purity

Strength

Love, Honor, Protect

Growth

Folk Art Animals

Many artists around the world use folk art to represent animals. Sometimes folk art is purely decorative, while in some cultures, the animals have spiritual meaning. Use animal shapes to make your own folk art. Divide animals into larger sections before adding details and color.

Dividing Your Drawings into Spaces

It's always helpful to divide a large space into just a few spaces before adding details to them. Try to do this to see the overall design before deciding on small details.

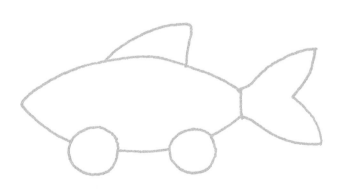

My Drawing Meditations

When I sit down to my morning art practice, I often make my own art start with watercolor pencils using the *wet-in-wet technique*, in which the colors are blended together without a line separating them. Start by applying the pencil to a dry surface and then dissolve the marks with a damp brush. Clean the brush, load it with a second color by stroking the lead, and then work it into the still wet surface. This method of blending takes away some of my control of the process. I revisit my art starts the second day with my pens and pencils. What comes from them is a spontaneous act of creativity.

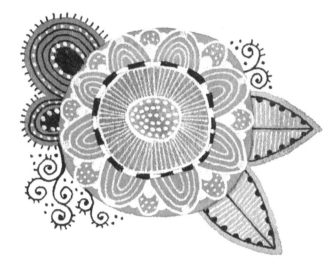

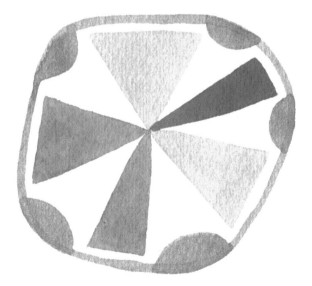

This week I give you two pages of colored art starts that are similar to mine. Pick one to draw on and around each day this week, and have all your pens and colors ready to go. Let the colors and shapes guide you, and don't forget to use the white space, too!

"When you do things from your soul, you feel a river moving in you, a joy." —RUMI

From Flow Comes Joy

Once you have drawn for some time, you'll understand that most things that you draw are made by merging shapes or altering their relationships to one another. In this section, you will practice doing just that. There are few art starts here; instead, I give you step-by-step instructions on how to draw things, which will help you understand how to draw other things. Once you have had the experience of how organically drawings come together, you'll discover the feeling of flow, what psychologist Mihaly Csikszentmihalyi defines as "the creative moment when a person is completely involved in an activity, for its own sake." And from that, comes joy.

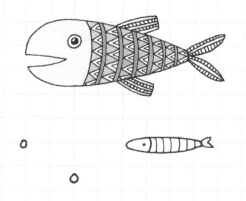

Easy Spirals and Paisleys

Spirals and paisleys are design elements that have been used for centuries. You can modify them endlessly, which makes them versatile and fun to draw.

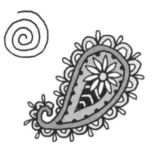

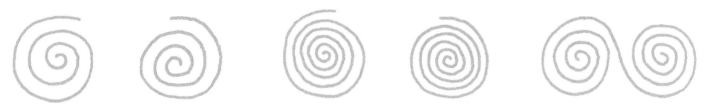

Day 1 Trace the art starts for the spirals going clockwise and counterclockwise. Then put two spirals together to make a double spiral. Practice doing these without the art starts.

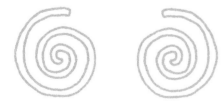

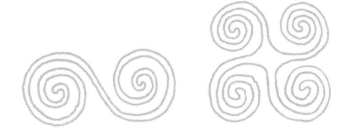

Day 2 To make a spiral "worm," draw a regular spiral with extra white space, moving from the center, and then make a U-turn and spiral out, being mindful of the width of the worm and the white space. Make a double. Practice without art starts. Make a pattern in the worm.

Day 3 Make a four-spiral motif, begin by following the art start, and then use the grid to help. Draw the spirals first, starting just inside the center corners, and then connect them. Then make your own spiral design.

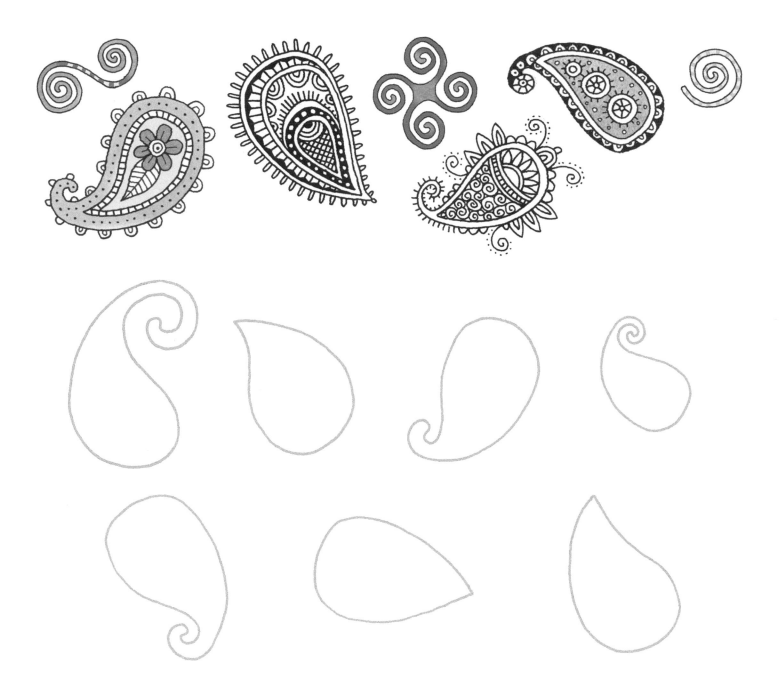

Days 4–7 Use the art starts to draw different paisley designs. Practice adding borders and design elements inside and outside. Draw some without the art starts and color your designs.

To make a paisley, start with a teardrop shape, connecting a circle to a triangle. Add a little hook or spiral to the top, and *voilà*! From there, you can make designs and borders inside or outside your shape.

Simple Mandalas

Mandalas are cosmic symbols that represent our relationship to the universe. Mandalas are often used as a tool to focus the mind for meditation or to establish a sacred space. To draw guidelines for a mandala, make several concentric circles of different widths with intersecting vertical and horizontal lines, and then split those angles in half again. Start your designs in the center and work your way outward, using the guidelines for balance. Then go in and add details such as patterns, doubled lines, and other embellishments. Try leaving white and dark areas for contrast.

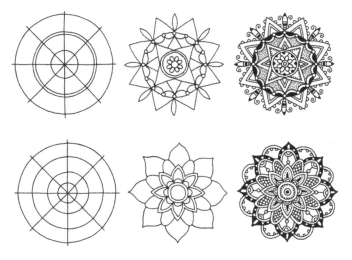

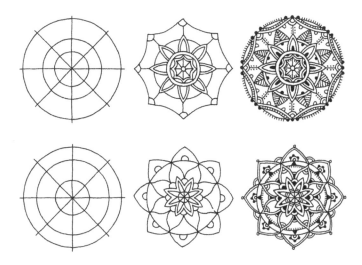

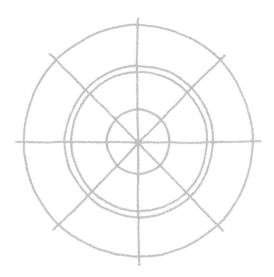

Days 1–4 Use the art starts to draw mandalas.
Day 5 Establish your circle widths to make your mandala.

Days 6 & 7 Make your own art starts and draw mandalas.

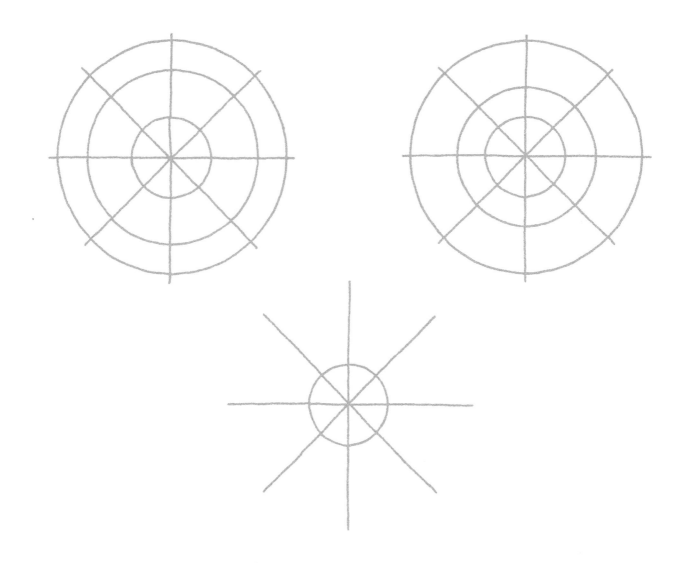

Snowflakes

The challenge with drawing snowflakes is to make the guidelines even. Other than that, they're a blank form for your joy and creativity. Use your imagination when adding design elements.

With a pencil, draw a circle with a center dot. Put an X in the circle and then a horizontal line across it.

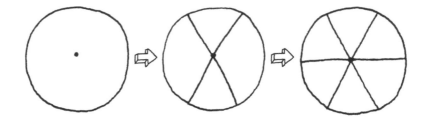

The goal is to get your angles even and your spokes the same length. Erase the circle and start drawing your snowflake!

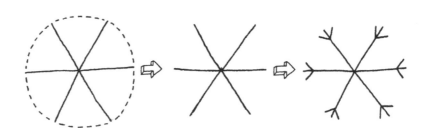

Day 1 Using the circle art starts, make your snowflake guidelines, and design several snowflakes, making sure that whatever you draw on one spoke, you draw on all of them.

Day 2 Using the space above, make your own guides and draw a few more snowflakes, adding different designs around the spokes. Try using the tick mark method of measuring described on page 95.

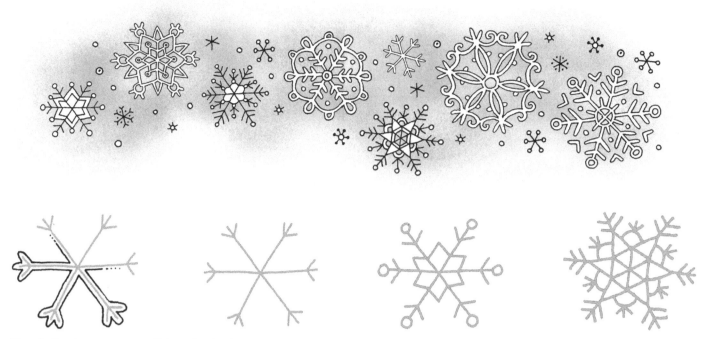

Day 3 To give your snowflakes depth, draw your design in pencil and then carefully draw an ink line around the pencil lines. Practice outlining these snowflakes.

Days 4-7 Practice drawing snowflakes using different designs and shapes to make each snowflake unique.

Measuring without a Ruler

Making tick marks along the edge of a piece of scrap paper is a great measuring tool when you're trying to keep spaces even and is much less clumsy than a ruler. Use the measurement from corner to tick mark or from one tick mark to the next to make even patterns, designs, or any repetitive aspect of a drawing.

Kaleidoscopes

A kaleidoscope design is a radial symmetrical form that's made by reflection using mirrors set at angles. Drawing a kaleidoscope can be a little tricky at first, but the surprise unfolds when the design comes together. Think of the edge of each wedge as a mirror, and follow these steps to learn to draw one.

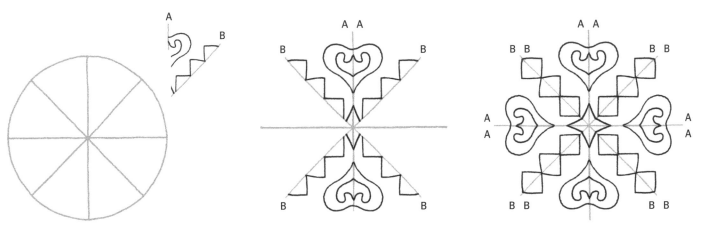

1. Divide a circle into quarters with horizontal and vertical lines, and then into eighths by dividing those spaces in half. Draw an asymmetrical design on one of the wedges. You can erase the outer edge of the circle, but make sure the spokes are the same length.

2. Draw the mirror image of that design on the wedge next to it. Then draw the mirror image of those two wedges on the opposite side.

3. Turn your page 90 degrees and repeat step 2.

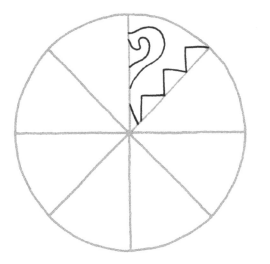

Day 1 Using the design on the wedge, make a kaleidoscope like the one in the step-by-step example above.

Day 2 Draw two simple designs on the wedges and choose one to make a kaleidoscope design.

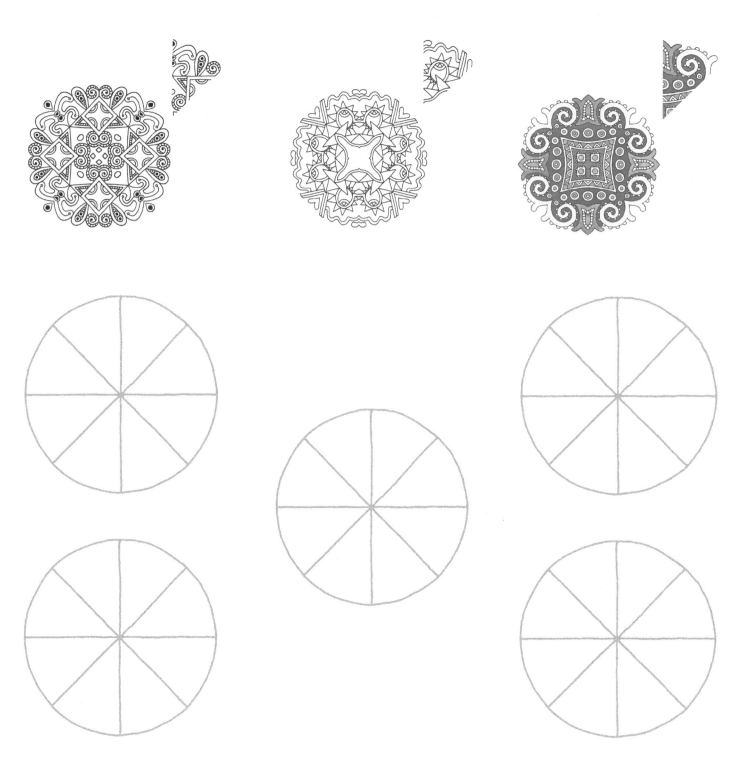

Days 3-7 For the next several days, make a kaleidoscope a day. Be sure to put in your larger dividing lines and shapes first to make sure you get your designs symmetrical. Above is an art start for the first day; make your own for the other days.

Using Grids to Create Patterns

Using a grid or concentric circles with spokes can help you make designs that are evenly spaced. You can use the intersections of points to help line things up, or the spaces within the lines, or even half of a space along a line.

Aviary

With a triangle, half circle, and circle, you can draw most any kind of bird. Soften the intersections and edges to get the shape you'd like. Add a beak, eyes, wing, and tail feathers, and then add fun and silly details. Change the position of the head, the length of the neck, the size of the tail, and the shape of the beak, and you've got a different bird. Draw a bird of your choice on the right-hand page each day this week.

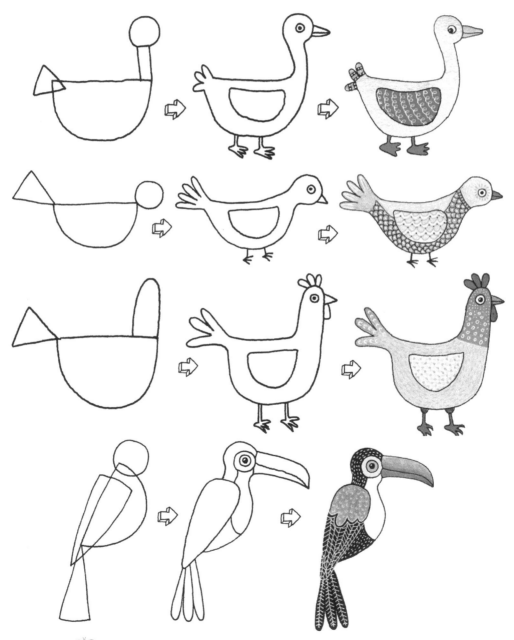

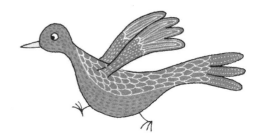

Coffee Mugs and Teacups

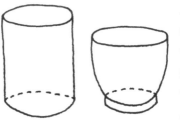

A good coffee mug is special. It needs to be the right size, feel good in the hands, and have an appealing design. It also is the vessel that contains my morning's beverage of choice. The shape is a basic cylinder, but both the body and the handles can vary quite a bit. They can slope in, out, or both, and the handles can be angular or curvy or anything in between. They may or may not have a base. On this page are some art starts for you to draw on, and the right-hand page is open for you to create your own mugs or cups. Have fun coloring them, too!

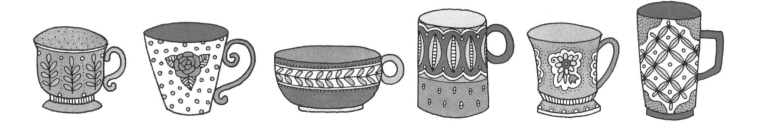

Go Fish

A fish is a fish—but there are so many different kinds and sizes and shapes!
By varying your shapes and sizes, you'll find that you have a sea of possibilities!
Below are examples of how to combine shapes to make a variety of fish. Use
these forms or design your own to make a school of fish on the right-hand page.
Don't forget patterns and colors, too!

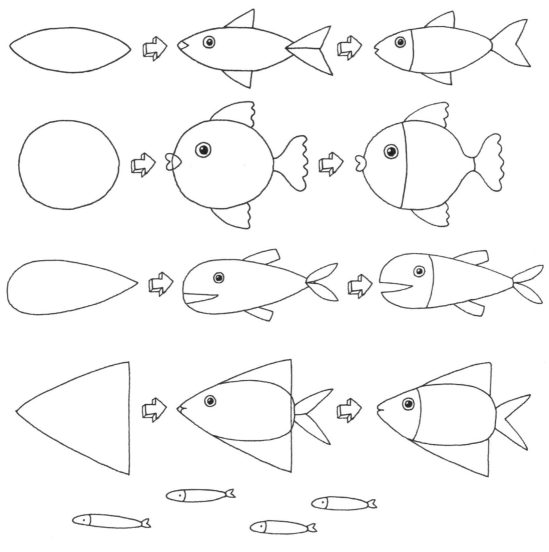

1 Draw the shape to the left in pencil. You can make it fatter
or longer—it doesn't matter.
2 Add the fins, tail, eyes, and mouth.

3 Soften the edges so the shapes flow into each other.
4 Ink your drawing, and then erase your pencil lines.
5 Color your fish.

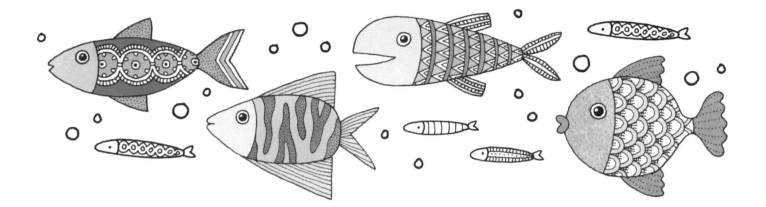

Make It Your Own

This week we draw designs that personalize objects. Design, draw, and doodle away. Think ahead about which spaces you want to fill and which you want to leave alone. Map out the basic design in pencil, draw major separating lines, and then follow with details and color. There is one item per day, and a couple of buttons for a little extra joy.

Wise Owls

As with other things we've covered, drawing an owl can be broken down into simple steps, starting with combining simple shapes. Once you've placed the basic shapes, you can modify them to make many varieties of owls. Follow the steps below to make your first owl on Day 1 this week and then continue to make owls on your own, changing whatever you'd like: the eyes, feathers, wing placement, or shape of the talons.

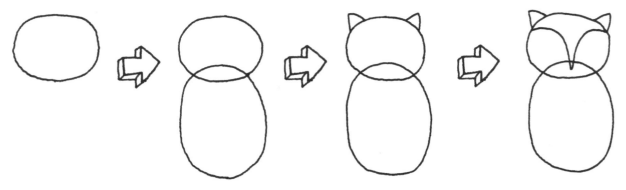

1 Draw a horizontal oval at the top of your paper.
2 Draw a vertical oval overlapping slightly under the first oval.

3 Draw two triangles at the top of the top oval.
4 Draw a rounded V from one corner of the triangle to the other, with the bottom extending into the overlapped space.

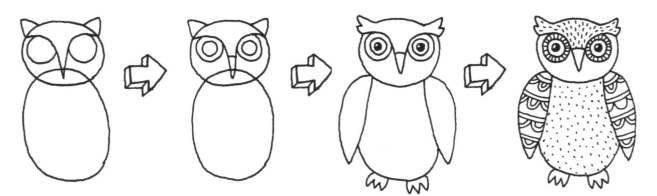

5 Draw two large circles under the rounded parts of your V.
6 Draw a horizontal line marking the beak and inner circles for the eyes.
7 Draw two more inner circles in the eyes and fill them in with black, leaving a symmetrical white mark for the highlights in the eyes.

8 Draw two banana shapes on both sides of the lower oval. Draw talons at the bottom of your owl. Ink your finished design and let dry. Erase the pencil lines and add textures, patterns, and colors to the various parts of your owl.

Complex Objects, Basic Shapes

As your drawings gain complexity, it will still be helpful to break down objects into a compilation of shapes. Here are examples of how putting together an assortment of shapes makes it easier to draw otherwise difficult forms. Follow and draw one of these examples every day this week, and use this handy technique to break down other objects into shapes.

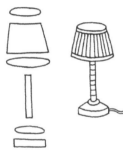

Day 1 Combine the oval shapes with the rectangles to draw a 3-D lamp.

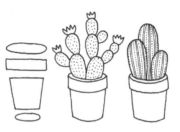

Day 2 Combine the oval shapes with the rectangles to make pots. Then use repeating ovals to draw the plants.

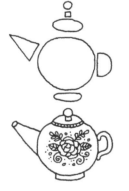

Day 3 Combine the shapes shown to draw the teapot. Soften the edges and modify the lines to make the spout and handle.

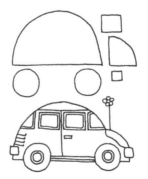

Day 4 Use the shapes above to draw a VW Beetle. Notice the relationship of the wheels to the body of the car.

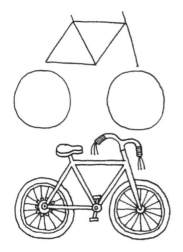

Day 5 Use the shapes above to draw a bicycle. It's all about the intersections of the shapes. Look carefully.

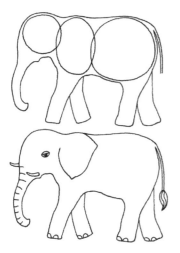

Days 6 & 7 Draw the shapes above to organize your elephant's body. Draw the ear in the middle oval, and add the trunk, legs, and tail. Add details such as tusks, eyes, and toenails last.

Making Faces

Learning to draw heads and faces well takes time and practice. Here are basic steps for drawing a front-view face that I hope will be helpful. One of the most surprising things is that the eyeline is halfway down from the top of the head! Vary the head, eye, nose, and mouth shapes, add some emotion, and you have an endless variety of faces. Use the guidelines and samples below as a start and practice drawing a head a day on the right-hand page this week! Next week we'll do hair and hats.

HEAD SHAPES

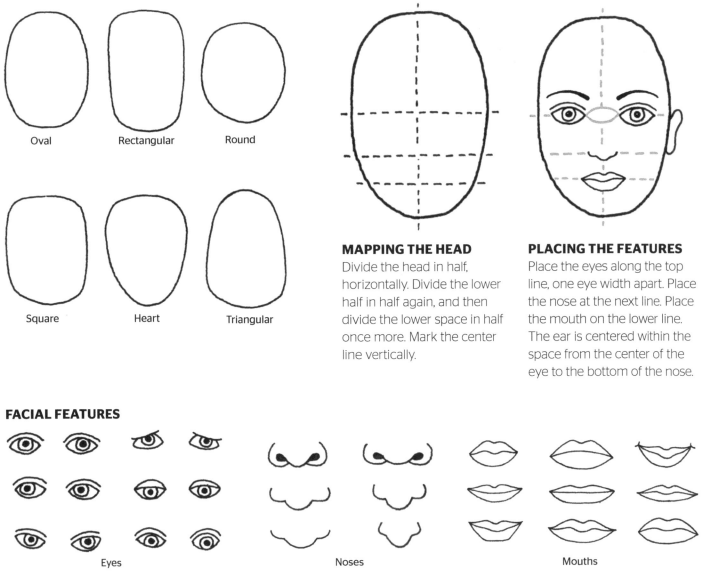

Oval Rectangular Round

Square Heart Triangular

MAPPING THE HEAD
Divide the head in half, horizontally. Divide the lower half in half again, and then divide the lower space in half once more. Mark the center line vertically.

PLACING THE FEATURES
Place the eyes along the top line, one eye width apart. Place the nose at the next line. Place the mouth on the lower line. The ear is centered within the space from the center of the eye to the bottom of the nose.

FACIAL FEATURES

Eyes Noses Mouths

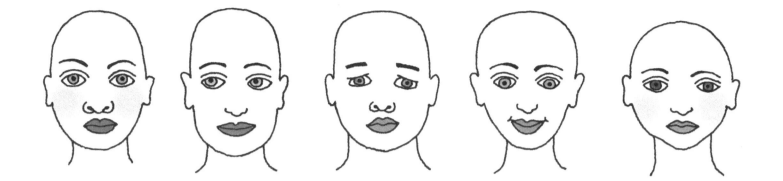

Bright Eyes

Adding a highlight to the eye will brighten a face considerably. As a final step, using a white pen, place a dot of white at the upper right or left of the iris, depending on the direction the light is coming from.

Hair and Hats

Now that you've practiced heads and faces (see pages 110–111), let's put some hair and hats on them! Hair is uneven. It grows in strands from the scalp going out and down, and it rarely forms a straight line where it ends on the forehead or bottom. Using the open space, practice drawing a head with hair and a hat each day this week.

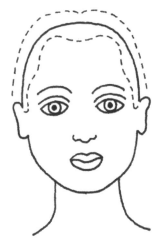

1 Draw hair as it frames the face first, starting in a bit from the skull (see dashed line).
2 Draw the rest of the hair in sections from front to back, and then draw in details. Add little loose or shorter hairs and curls to give it life and irregularity.
3 Waves go in different directions, and curly hair goes in every direction.
4 The more body the hair has, the farther away it sits from the skull.

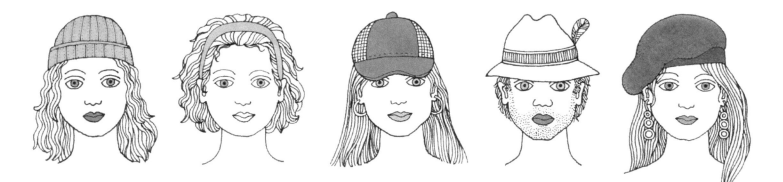

5 Hats are designed to fit heads and not hair (hence the term "hat head"). The crown of a hat should sit approximately 1" to 1½" (2.5 to 3.8 cm) above the eyebrows. When drawing a hat on a head, the line where the crown meets the face should be curved in the direction the hat is tipped.

Freeform Doodles

One way to start a doodle is to draw a loose, freeform line that establishes the spaces you use to draw in and around. I've made the squiggly lines for you, so this week you can spend time each day drawing patterns in and around them. Enjoy!

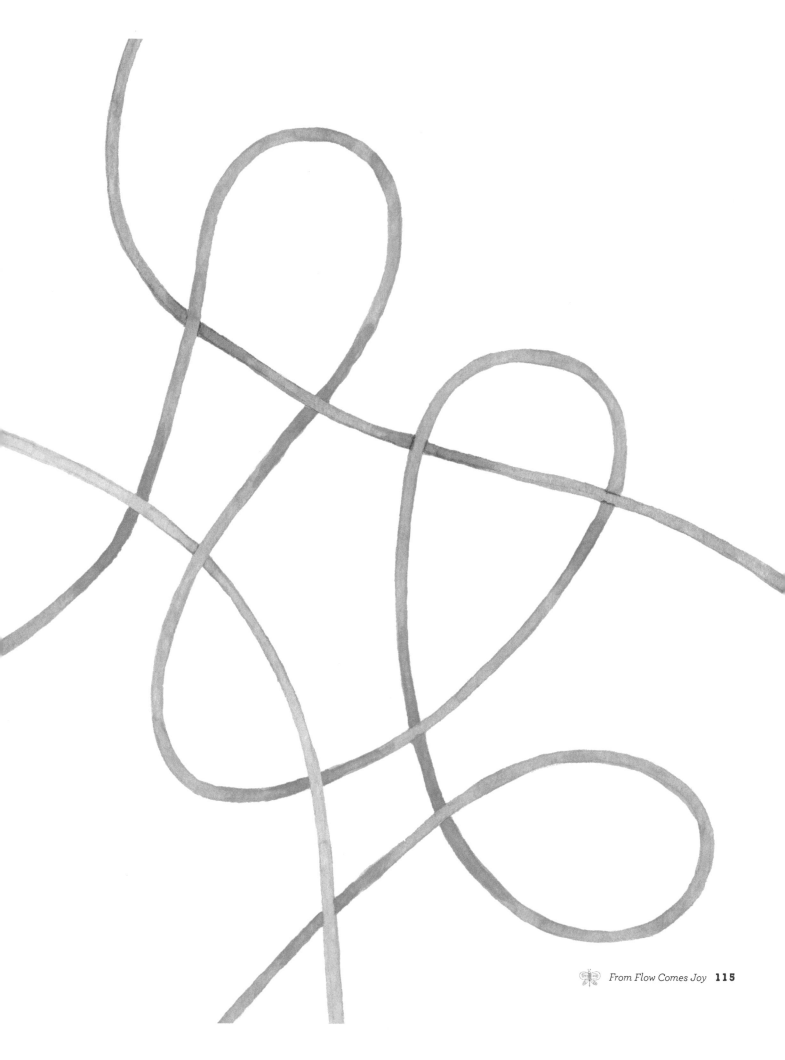

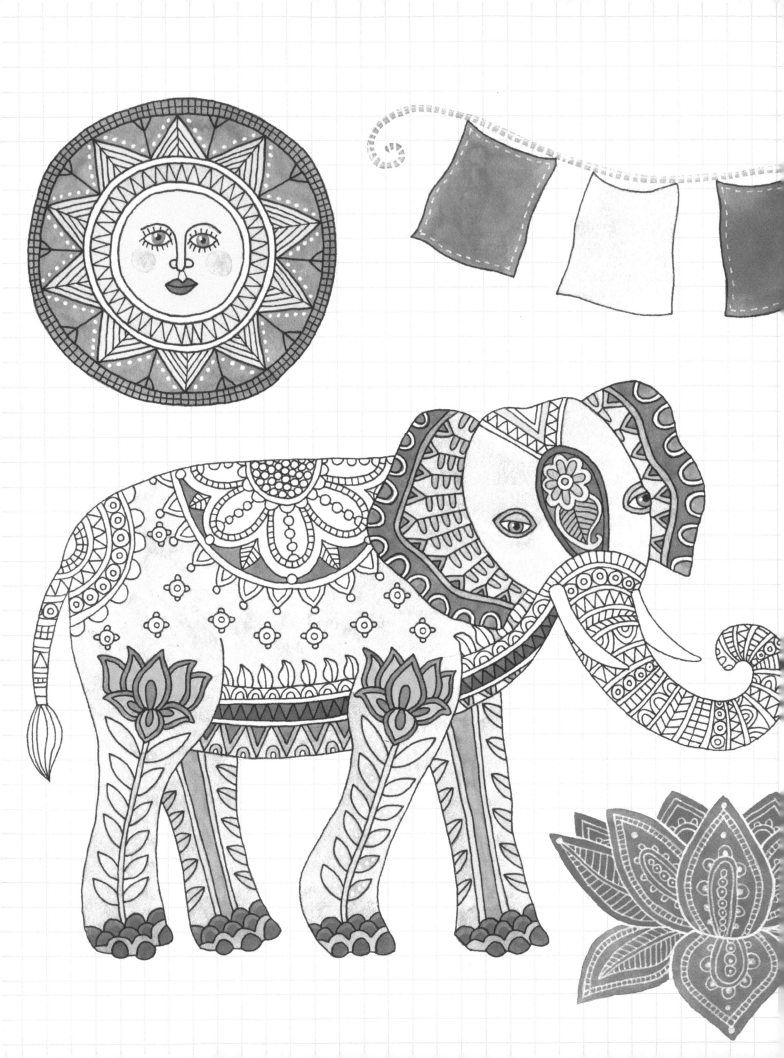

"Art washes away from the soul the dust of everyday life." –PICASSO

Joy Happens

I hope by now you're feeling the joy as you sit down to your daily art practice. Isn't it great? I think so. As your skills develop and your practice flows, we add complexity to the prompts. In this last section, you'll work on your drawings for anywhere from a single day to up to a week. You determine how to combine shapes, block out the bigger areas first, and use your imagination to add creative touches such as patterns, borders, and details. The hardest part will be limiting your time each day. All that joy can be addictive!

Seven Wishes

Prayer flags date back to pre-Buddhist Tibet. Meaningful symbols, prayers, and intentions are placed on rectangular flags; when activated by the wind, the flags and their messages of peace, compassion, and strength are carried to people everywhere. People touched by these messages carried on the wind are a little happier. Traditionally, prayer flags are placed in a row of five colors, representing the five elements: red for fire, yellow for earth, green for water, blue for sky or space, and white for air or wind. Given our unsettling times, what messages will you spread to all people?

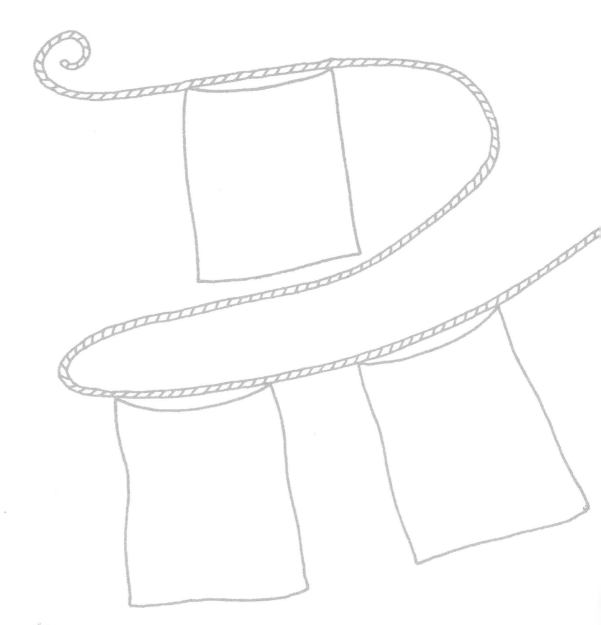

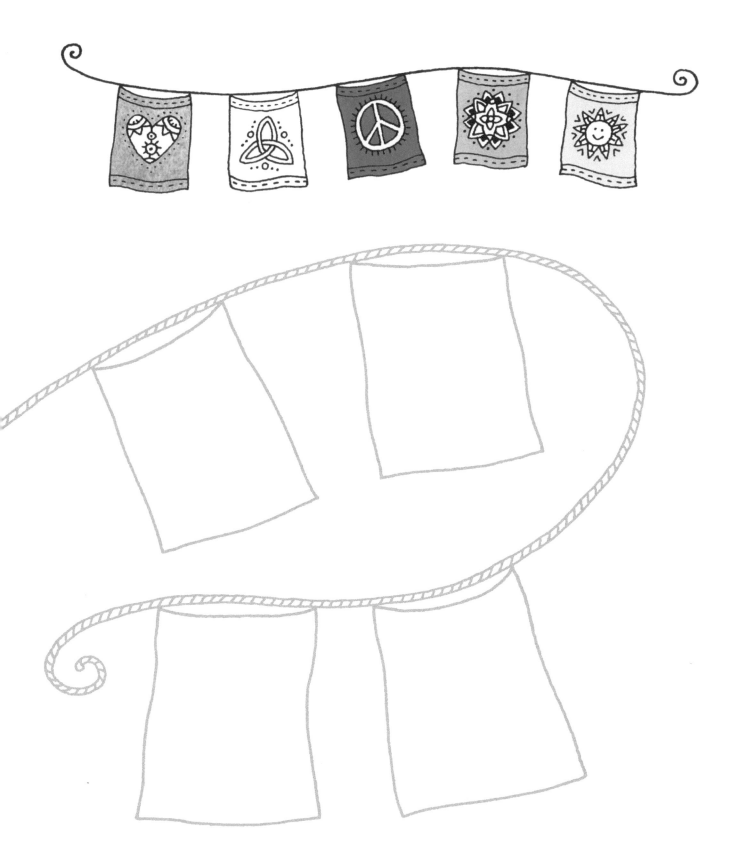

Wall of Flowers

You've drawn bricks, stones, wood, and frames. You've practiced flowers and leaves, decorated teacups, and made your own folk art and patterns. Here's a wall of flower pots and vases to spend your practice time with this week. You know what to do! Have fun.

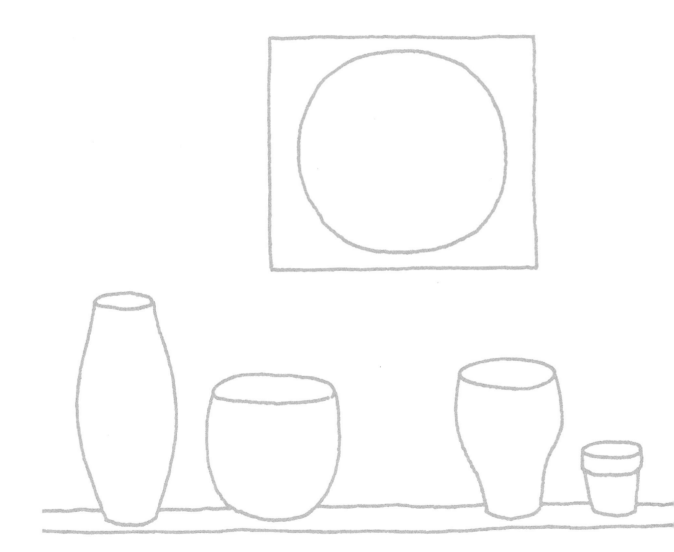

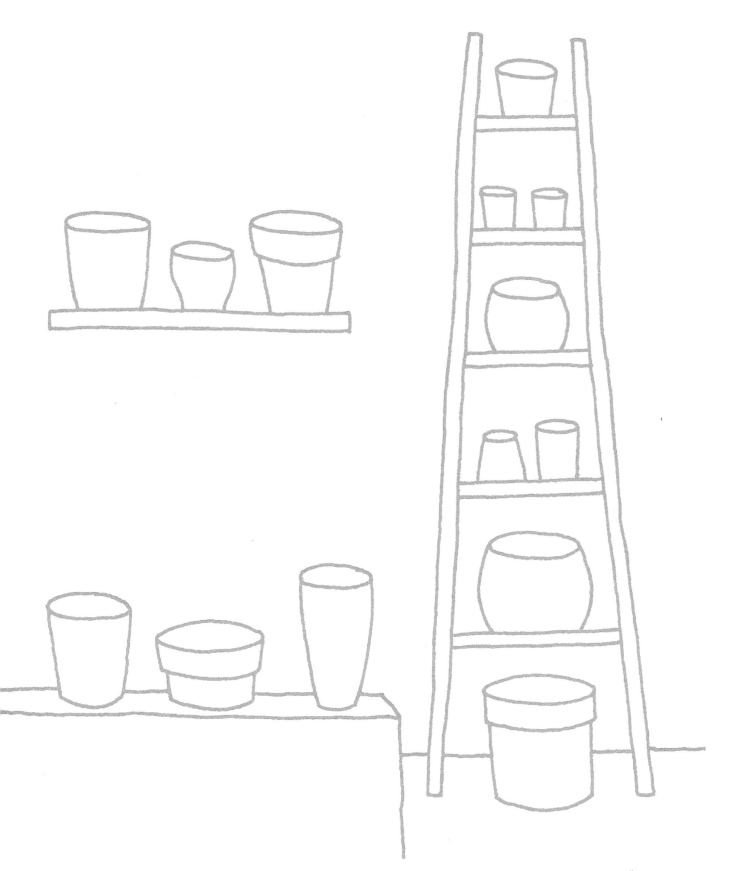

Here Comes the Sun

I love to draw suns because they're such a happy and universal image. Drawing a sun is like drawing a mandala. Inside the central circle can be a face, or not, and the rays that come out from the center can be represented in a million different ways. The position of facial features on a sun is a little higher than it would be on a person (see page 110). Use the space on the right-hand page this week to draw a variety of suns. The examples on this page are for inspiration; feel free to make up your own.

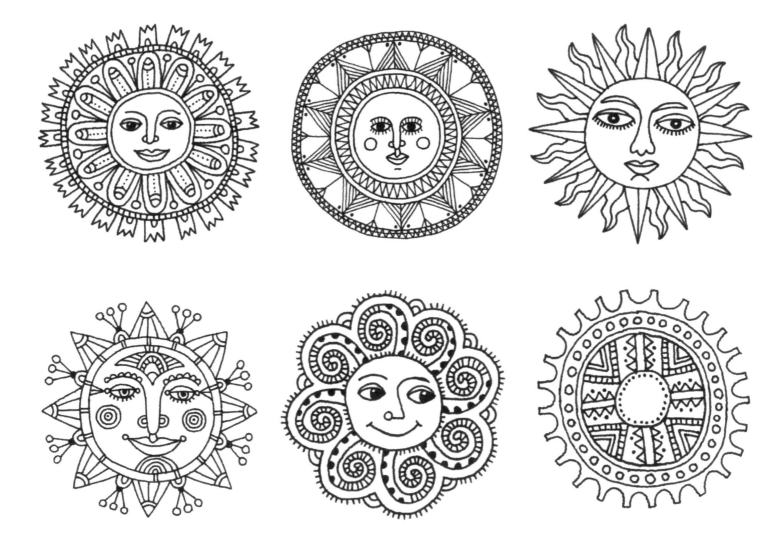

Fancy Flowers

There are so many ways to draw flowers. Start with a basic flower shape. Use overlapping petals and allow your flowers to have organic variations. Below are some ideas for taking your flowers to the next level. On the right-hand page, make a flower each day this week. Combine several flowers together!

Add leaves to a flower and then use texture to differentiate each area.

Combine several different flowers into one.

Embellish the outer edge of a radial flower.

Make radial designs in the center and add flower dust.

Use organic shapes.

Make flowers grow out of other flowers.

Add stamens and an unexpected pattern.

Create a large motif with a variety of petals, leaves, and other details.

Add strong contrast and spirals.

Hot Air Balloons

Another fun thing to draw is a hot air balloon. The construction is simple—basically, it's a circle connected to a trapezoid, and the basket is a modified square. Once you have your basic shape, then you can have lots of fun with the balloon itself. Many ballons are brightly colored, and the designs should be drawn with curves that emphasize the shape of the balloon. Consider whether you are looking at the balloon straight on or from above (or below). You have one art start on this page and plenty of space to make more balloons on the right.

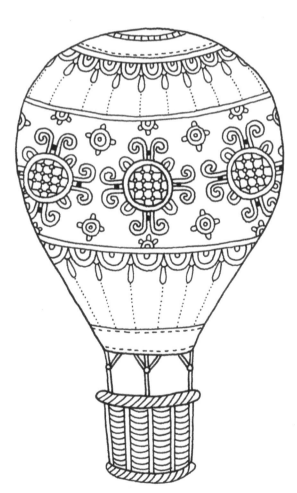

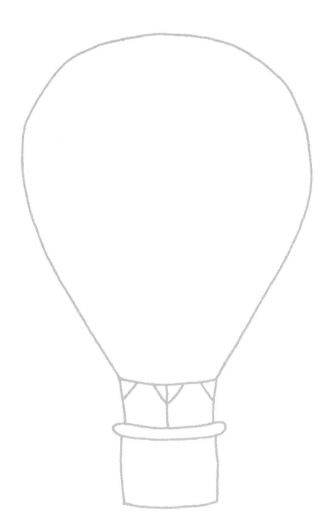

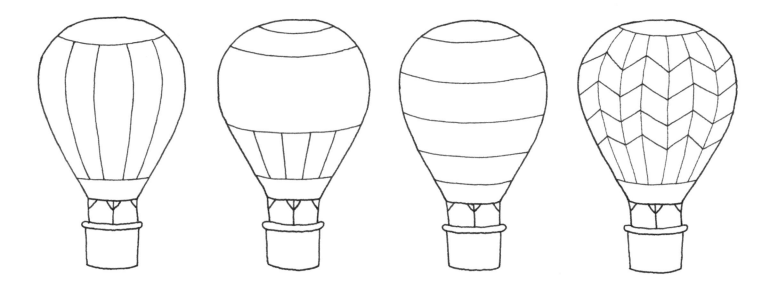

Complex Mandalas

Mandalas are one of my favorite things to draw. Time stands still as I get lost in the shapes and patterns as the design comes together. As your skills develop and your drawings become more complex, your guidelines will help you keep your drawings balanced. Use them only to guide you, however, and not to determine the placement of the elements of line, shape, value, and pattern. Have fun!

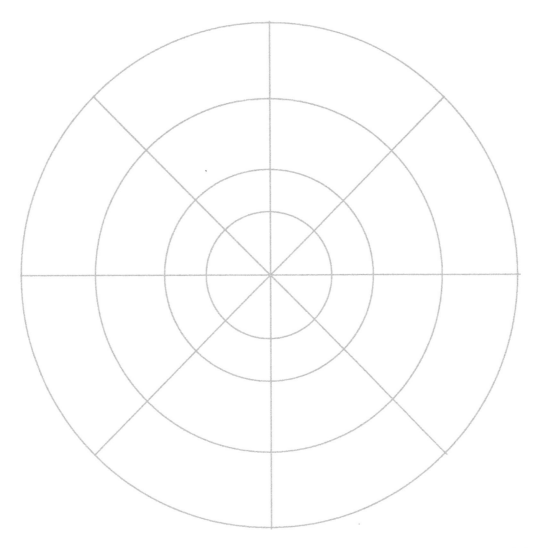

Days 1–3 Using the art start, begin your drawing from the smallest circle and move outward, using the circles and spokes as needed to help with the balance of elements.

Turn the page around as you add lines and shapes. Add patterns and borders at the end and make sure to vary the values for visual interest.

Days 4-7 Make circles and spoke guidelines to draw two more mandalas, playing with different shapes and textures for the rest of the week.

Lotus Flowers

In the Buddhist tradition, the lotus flower is a symbol of purity, rebirth, and divinity. It is a popular symbol in the world of yoga and another great image to draw.

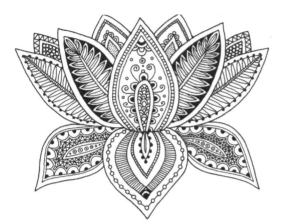

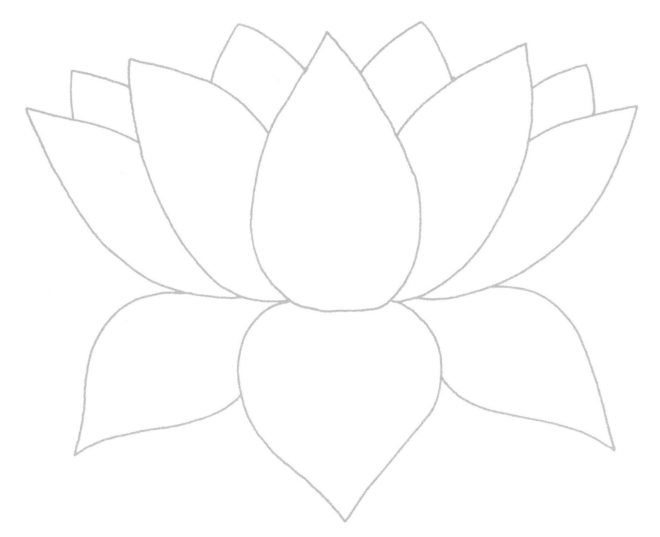

Days 1-3 Use the art start to create a lotus flower with your own embellishments

Days 4-7 Use the sequence at the top of the right page to draw a lotus flower, adapting it to your aesthetic. Have fun with the petals, varying them for interest.

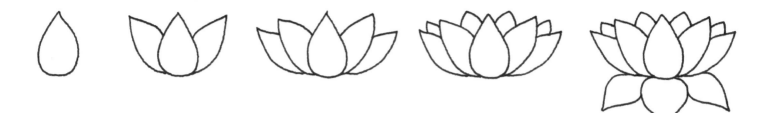

Mehndi Hand Tattoos

This week we put our skills to use designing a mehndi tattoo (or two).

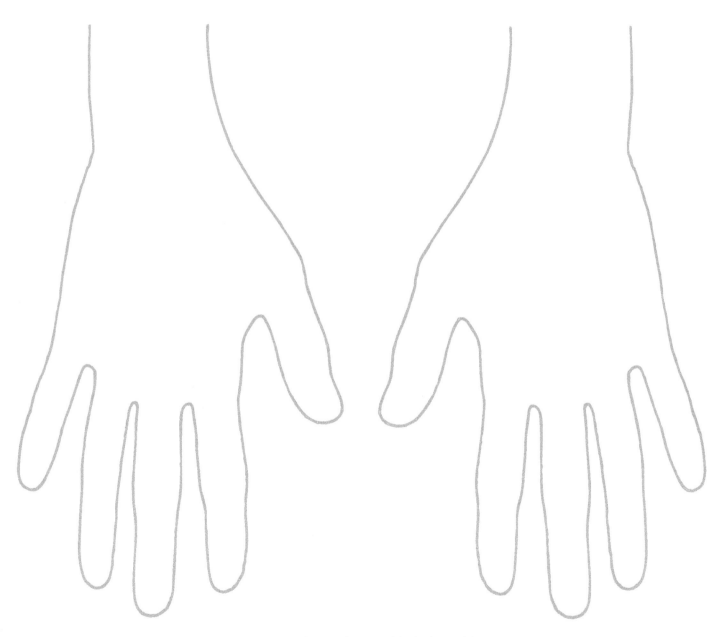

Day 1 Using a light pencil line, divide the blank hands into shapes with design guides.

Days 2–4 Start with larger spaces and then move to smaller details.

Days 5–7 Trust your intuition and embellish your design with smaller patterns and details.

Pattern Play Sugar Skulls

Sugar skulls are often made from sugar and candy and are a symbol of Dia de Los Muertos. Taking place on All Saints' Day in Mexico, Dia de Los Muertos recognizes death as a natural part of the human experience. The dead are awakened from their eternal sleep to share in celebrations. Bright colors, fancy costumes, food, and entertainment are all part of the festivities. The sugar skull is a popular image and is lots of fun to embellish and decorate.

As with all complex images, begin by mapping out the larger areas with pencil before adding details. Notice that the placement of the eyes on the skull is higher than on a natural face. Use the image at right as an example and have fun using the art start on the right-hand page to draw your own sugar skull each day this week. Watch your time—it's addictive!

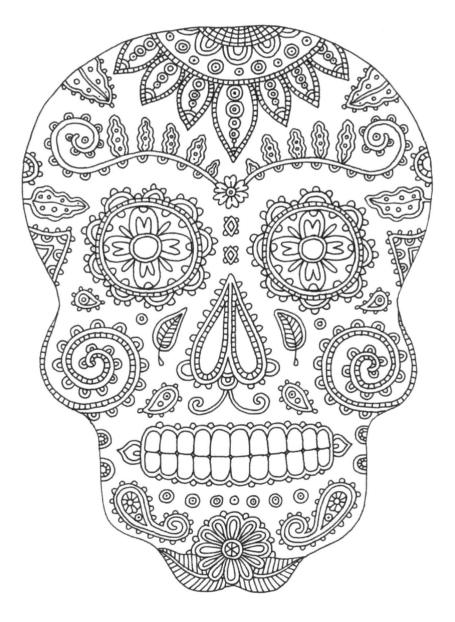

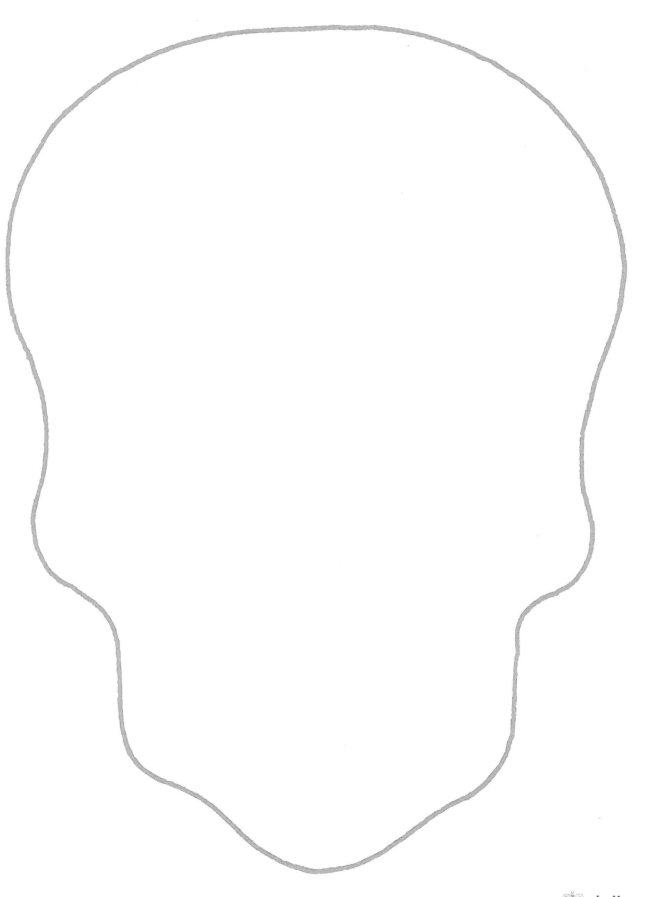

Ears, Trunk, Tusks

Depending on the culture, elephants symbolize wisdom, good luck, and happiness, and are admired for their memory and high intelligence. Ganesha, represented by a cross-legged elephant, is a Hindu god whose primary function is to remove obstacles from mortals' paths. Using the example as a guideline, map out the sections for your design using the art start on this page. Take a couple of days to add the details. Then, starting from scratch, draw your own elephant on the right-hand page during the remaining days this week.

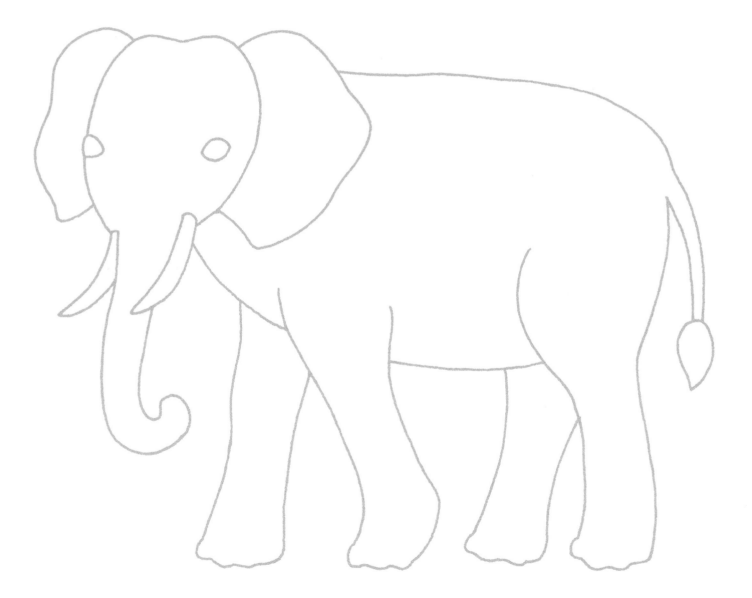

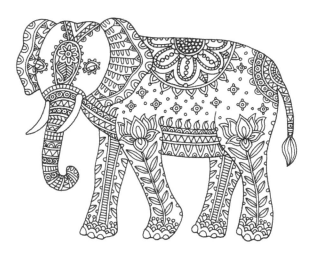

Deep Sea Creatures

These are two of the many beautiful sea creatures that are fun to draw. Both the octopus and the squid have eight arms, but the squid has two tentacles that are much longer than the arms and two fins. Draw the arms with a single line and then add width to it by drawing a slightly overlapping line on each side. Overlap the arms to show depth and movement. Position all the arms and tentacles before going over with ink and then erase your pencil lines and start to add your details. The amount of realism you use is completely up to you!

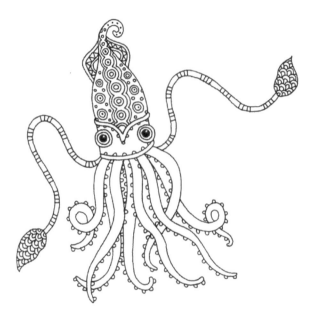

This week spend 15 minutes a day drawing octopi and squid. You may want to set a timer so you don't get carried away!

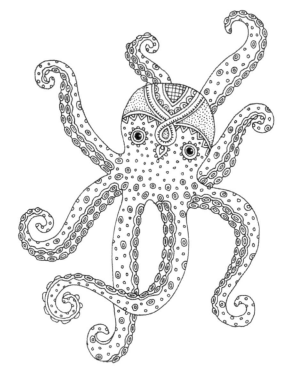

Freeform Drawing

Let your lines and patterns flow. No planning allowed! Take 15 minutes each day this week and draw a freeform doodle, letting it evolve from one day to the next. You can either build on my art start in the corner or begin your own.

Resources

When you've finished the exercises in this book, I hope you'll reflect on the experience and realize how much you've accomplished. Where do you go from here? Perhaps you'll get yourself a blank journal and continue drawing every day, or you might want to move on to observational drawing. Maybe you'd like to stick with prompts or find a Facebook or Instagram community to check into. There are so many resources available to help you continue along this path, learning more about having a daily practice of both meditation and drawing. There's even a prompt generator online called artprompts. org! Here are a few suggestions to get you started.

Art Supplies

www.cheapjoes.com
www.dickblick.com
www.jerrysartarama.com
www.jetpens.com
www.joann.com
www.michaels.com
www.utrechtart.com

Books

Here are several books on meditation by authors I have either read or deeply respect.

Chödrön, Pema. *How to Meditate: A Practical Guide to Making Friends with Your Mind.* Louisville, Colorado: Sounds True, 2013.

Gregory, Danny. *Art Before Breakfast: A Zillion Ways to Be More Creative No Matter How Busy You Are.* San Francisco: Chronicle Books, 2015.

Hendrix, John. *Drawing Is Magic: Discovering Yourself in a Sketchbook.* New York: Stewart, Tabori and Chang, 2015.

Kornfield, Jack. *Meditation for Beginners.* Louisville, Colorado: Sounds True, 2008.

Salzberg, Sharon. *Real Happiness: The Power of Meditation: A 28-Day Program.* New York: Workman Publishing, 2010.

Tharp, Twyla. *The Creative Habit: Learn It and Use It for Life.* New York: Simon & Schuster, 2006.

Cool Artists Who Draw Everyday

www.katebingamanburt.com
www.thedrawingmind.com

Meditation and Retreat Centers

Insight Meditation Society
Barre, Massachusetts
www.dharma.org

Kripalu
Stockbridge, Massachusetts
www.kripalu.org

Shambhala Mountain Center
Red Feather Lakes, Colorado
www.shambhalamountain.org

Spirit Rock Meditation Center
Woodacre, California
www.spiritrock.org

Online Classes

To learn more about drawing, take a class at your local community college, art school, or online. Both Cheap Joe's and Jerry's Artarama have free lessons and videos on their websites. Other great sites include:
www.craftsy.com
www.creativebug.com
www.skillshare.com

Acknowledgments

Thank you:

To the **neighborhood kids**, who gathered around the coffee table, drawing, where the seed was planted.

To my friend and neighbor, **Janine Webb**, who brought my artwork to Quarto and said, "You must work with this artist!"

To **Joy Aquilino**, my editor, who has kindly and graciously supported me through this project.

To **Mary Ann Hall**, editorial director at Quarry Books, who believed in me and my big idea.

Much gratitude to my community of **friends on Facebook**, whose many likes and loves and comments have inspired me every day.

To the many gifted teachers I've had, including **Jim Trifone**, **Mona Costantini, Amy Alpers, Rachel Segel, Jeanne Anselmo**, **Sharon Salzberg**, and **Stephen Cope**. You have made my life better.

For the inspiration and immense love of **Father John Giuliani**, **Sister Kathleen Deignan**, and the most amazing community at the **Benedictine Grange**.

To my **Uncle Frank**, who taught me that I can do pretty much anything I set my mind to, and has stood right by me my entire life.

Deep love and thanks to **Pip Jones**: husband, photographer, power tool, and Photoshop expert, who believes in me and is always willing to jump in and help me with whatever crazy idea or emergency I have.

And to my **dear girlfriends** (you know who you are) whose love and support transcends time and miles. I so love you.

About the Author

Artist and illustrator **Stephanie Peterson Jones** loves creating illustration and design. You can find her work decorating the pages of children's books, adult coloring books, textiles, stationery, and gift products. Working in both traditional (watercolor and gouache) and digital media, often in combination, she is known for her bright and cheerful illustrations, graphic surface patterns, intricate ink drawings, floor mandalas, and nice handwriting. Stephanie has illustrated many children's books, among them the award-winning *Peek-a-Moo*, in print since 1999, and has licensed her artwork to textile, stationery, and gift companies worldwide. Most recently, her book *Where's My Nose?* was chosen by Dolly Parton to be part of her Imagination Library.

Her clients include Calypso Cards, Taunton Press, Round World, Graphique de France, Penguin for Young Readers, The Giftwrap Company, BIC, CR Gibson, Pelican Bay, and many more.

After earning a master's degree and starting her daily art and meditation practice, she taught middle school for several years, which she now chalks up to be a learning experience leading her to this book. She is now a full-time illustrator and part-time Pilates teacher.

Stephanie and her husband, Paul, recently moved from Fairfield, Connecticut, to Asheville, North Carolina. Before they moved, they collaborated to form Art and Kindness, a repurposed art project where they made decorative fish and flags by repurposing picket fences damaged in Hurricane Sandy. They donated a portion of the sales to families affected by disasters.

Stephanie currently maintains a daily drawing practice and feels a little bit off when she misses a day. She is inspired by beauty in nature, kind people, and the little visual surprises she encounters each day. When she's not making art, she's taking a hike, knitting, making pottery, and teaching (or doing) Pilates.

Stephanie would love to hear from you. Visit her at
www.stephaniepetersonjones.com
www.facebook.com/StephaniePetersonJones
www.instagram.com/peetyjones
www.etsy.com/shop/peetyjonesetsyshop (pending)
twitter: @peetyjones

CPSIA information can be obtained
at www.ICGtesting.com
Printed in the USA
LVHW07s0959080318
R13298800006B/R132988PG568550LVX8B/2/P

9 781631 592959